La storia raccontata

26

Renzo Manetti

THE LANGUAGE OF THE ANGELS

Symbols and Secrets
in the Basilica of San Miniato in Florence

Edizioni Polistampa

Original title: *La lingua degli angeli* (Polistampa 2009)

Translated from the italian by Stephen Tobin

Jacket illustration:
The zodiac of San Miniato

© 2011 EDIZIONI POLISTAMPA
 Via Livorno, 8/32 - 50142 Firenze
 Tel. 055 737871 (15 linee)
 info@polistampa.com - www.polistampa.com

ISBN 978-88-596-0947-6

CONTENTS

.

INTRODUCTION

Set into the marble floor of the Basilica of San Miniato in Florence, between the main door and an arcane depiction of the Zodiac, the visitor encounters a mysterious inscription dated 1207, which has been interpreted in many different ways:

"hic valvis ante, celesti numine dante; mccvii.re
metricus et iudex. hoc fecit condere joseph;.tinent de
ergo rogo cristum. quod semper vivat in ipsum;.tepor mte"

Everything seemed to me to point to the existence of a second, hidden meaning lurking beneath the literal translation. Pointers in that direction included the ambiguous use of terms that can have a dual meaning, such as *valvis,* which can mean either a "half-shell" or the "wing of a door"; or the word *ipsum* in the last line, which can refer both to Christ and to the church itself. But the thing that intrigued me most was the obscure reference to a secret which appeared to be capable of preventing death and halting the march of time. If you take the last two words at the end of each line and string them together, you will find that they form a complete sentence which has nothing to do with the rest of the inscription. Indeed, it appears to have been deliberately concealed: *"1207. Retinent de tempore et morte"*. In other words: "these things preserve from time and death". It clearly wasn't a later addition because the whole inscription was carved on a single slab of marble. So the way the words were laid out seemed to have been specifically designed to make them difficult to interpret. Why? Who or what prevents time and death from pursuing their course?

The name Joseph aroused my curiosity too. It is a Jewish name and was uncommon among Christians at that time. Indeed, a search in numerous Florentine documents cited in texts and registers of the period revealed not

a single instance of a Florentine Joseph, and certainly not a *iudex* or a *metricus* of that name. Yet there was one exception, and a significant one at that. A document dated 1218 mentioned an abbot of San Miniato by the name of Joseph. That struck me as such a bizarre coincidence that I was immediately prompted to identify the Joseph in the inscription with Joseph the abbot. But who was this Joseph? Could a Jew really have become an abbot? Could the wisdom of the Kabbalah and Christian Hermeticism really have come together in his person? The elaborate sacred geometry of the façade and the symbolism of the marble floor certainly appeared to imply familiarity with those doctrines and to confirm the presence of a secret truth concealed among the walls and marble inlays of the great basilica. Was the inscription, then, referring to that truth?

This was the question that prompted me to undertake a study which led me, year after year, to discover what were the often surprising answers that I outlined in my book "The Gates of Heaven: Secrets of Sacred Architecture" (1999). It was only later that I realised the content of these symbols could perhaps be better explained through enigmas and parables, and it was that realisation that spawned the historical novel—although "allegorical tale" might be a better definition—called "The Secret of San Miniato" (2006). An exhibition and a catalogue entitled "10 Centuries for the Basilica of San Miniato al Monte" allowed me to make several additional and original contributions to the topic in 2008.

But the basilica is a compendium of wisdom that demands patience in the reading of it because it is written with symbols, with the language of the angels. This language has the sublime ability constantly to renew itself and each reading reveals new meanings. Thus I felt the need to draw a line in my studies, to take stock of the situation and come up with a solution for the novel's many readers who were asking me where they could get hold of "The Gates of Heaven", which is unfortunately now out of print. Hence this new book, which provides a state-of-the-art picture of my research to date. One might almost call it the novel's hidden face because the two books complement and complete one another, each one containing something its twin is missing. This book explains the symbols, but only the novel offers the key to understanding them.

Renzo Manetti

1. THE BASILICA OF SAN MINIATO IN FLORENCE

The Roman colony of Florentia reached the height of its prosperity in the 3rd century A.D., becoming the capital of the VII Regio of Etruria. Christianity came to the city with Greek-speaking merchants from Syria who settled in the crowded suburb that had grown up outside the walls, just across the only bridge over the river Arno and not far from the hill of San Miniato. By the 6th century these merchants had acquired considerable wealth and a reputation for authoritativeness. Many of them appear to have hailed originally from the city of Apamea, to the south of Antioch, and indeed most of the names found in the city's paleochristian cemeteries appear to be Greek in origin. Until the 12th century, Good Friday prayers in the churches of Florence were still said in Greek, a clear legacy of a tradition with which the populace no longer identified[1]. Florence shared this liturgical link to the Syriac church (as opposed to the church of Rome) with Milan. The visit to Florence in 394 of Milan's bishop, St. Ambrose, testifies to the bond between the two cities' Christian communities. While in Florence, Ambrose consecrated the new basilica of San Lorenzo, and some two centuries later even the city's first cathedral was named after a Syrian saint, Santa Reparata. There is evidence that the Florentine church's ties with the east continued over the ensuing centuries. The patriarch and archdeacon of Jerusalem right up until the 13th century were often of Florentine extraction. Following an agreement with Bishop Pietro in 1204, Patriarch Haymar (or Aimaro) of Jerusalem, who was also a Florentine, made a gift to the city of no less a relic than the Apostle Philip's arm to seal the strong religious bond between the two cities. Most of the Baptistry's exterior decoration probably dates from

[1] Robert Davidsohn, "Forschungen zur älteren Geschichte von Florenz", 8 volumes, Berlin, 1896-1908; vol. I, pp. 995-996, p. 64.

this time and may well have been designed in preparation for the solemn event.

Miniato, whose name (Minias) reveals his membership of the Greek Syriac community, was martyred on 25 October 250 during the persecution ordered by the Emperor Decius. His body was buried in a cemetery situated on the summit of the hill known as Arx Vetus (Arcetri), and a small church with a hermit's cell was built over the place where he had met his death. By the 8th century Miniato was being venerated as the patron saint of Florence. In 783 the Emperor Charlemagne made over some land on the hill which, being royal property, was known as the Monte del Re or King's Mount at the time, to the *"Basilica of Christ's martyr St. Miniato, situated in Florence where his venerable body rests"*[2]. Thus by that time the church had clearly grown large enough to be considered a basilica. The donation was added to by King Lambert in 898 when he gifted more land in the area, although this time he donated the land directly to the Florentine church of San Giovanni (St. John), which suggests that the basilica of San Miniato was now under the direct jurisdiction of the city's bishop. King Berengar further increased the property in the following year, and on that occasion the diocese of Florence was said to be under the patronage of both St. John and St. Miniato. Otto II took a community of cloistered nuns housed in San Miniato under his protective wing in 971, which implies that by then the monastery and its property had been relegated to the sidelines of city life. We may also assume that the decline which so shocked Bishop Hildebrand a few years later had already set in. Alongside the church of San Miniato there may well have been another church on the same hill, dedicated to St. John, who, as we have seen, was the city's other patron. Davidsohn thought that the second church, which was still being mentioned in 1024, stood where San Salvatore al Monte was subsequently to be erected in the late 15th century. There would be nothing strange in that. After all, down in the city there was a second church dedicated to San Miniato just as the immense Baptistry was dedicated to St. John. Thus both Florence's patron saints were commemorated within the walls and on the hill.

A dispute between the cathedral canons and the bishop resulted in the bishopric being given sole use of the Baptistry and the canons sole use of

[2] *"Basilica Sancti Miniatis martiris Christi sita in Florentia ubi eius venerabile corpus requiescit"* cit. in Mario Lopes Pegna, "Firenze dalle origini al Medioevo", Florence, Del Re, 1974, p. 288.

Santa Reparata. Thus the Baptistry of San Giovanni was the city's true cathedral—the church containing the bishop's throne, or *cathedra*—in the 11th and 12th centuries. This may well be what prompted Bishop Hildebrand in 1018 to found a new episcopal church on top of the sacred hill which, along with San Giovanni, was the property of the bishopric[3]. Thus we can clearly see the close link that was established from then on between the ancient Baptistry inside the walls and the new sacred citadel on the hill.

The old church of San Miniato was in a parlous state by the start of the 11th century, and Bishop Hildebrand found it abandoned and on the verge of collapse. For his grandiose reconstruction project he managed to win both the approval and the financial assistance of Emperor Henry II, whom he had accompanied to Rome for his coronation in 1014. Construction work proceeded so rapidly that Hildebrand was able to send a community of monks to inhabit the new monastery within the space of a few years. The first abbot, Drogo, penned a new version of St. Miniato's life, in which he set out to justify such a grandiose and expensive building project. Hildebrand also took care to endow his new foundation with a large temporal estate, including the *"court of Empoli in the parish of St. Andrew"*, whose special significance can be surmised from the fact that the façade of the church is modelled on that of the mother church, San Miniato itself. The bishop was able to consecrate the new basilica on 27 April 1018.

In an act dated 1062, Henry IV called the building *"decenter constructum"*, meaning that it was to all intents and purposes finished. There is a widely held view among scholars, however, that construction work actually continued throughout the 12th century and that 1207, the date inscribed on the basilica's marble-inlay floor, may be taken as the year in which work was finally complete.

The basilica of San Miniato (fig. 1) has a central nave and two side aisles which extend into a choir raised above the crypt and end in a single,

[3] *"The church of San Miniato... crowned... the amibitious project of establishing an episcopal acropolis on which to reproduce on the hill strategically dominating the city the new symbols of the bishop's prestige: a new cathedral founded on the relics of a martyr, a plebs, and a monastry where loyal monks – rather than quarrelsome canons – would sustain his political and pastoral action"*: Anna Benvenuti, "Stratigrafie della memoria: scritture agiografiche e mutamenti architettonici nella vicenda del Complesso cattedrale fiorentino" in AA.VV. "Il Bel San Giovanni e Santa Maria del Fiore. Il centro religioso di Firenze dal Tardo Antico al Rinascimento" edited by D. Cardini, Florence, Le Lettere, 1996, p. 118.

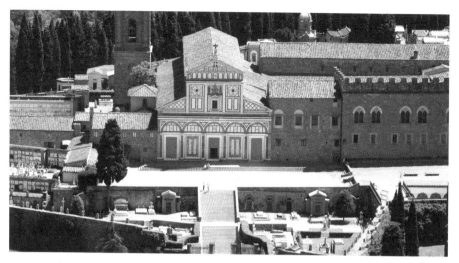

Fig. 1 - *The Basilica of San Miniato*

central apse. The nave and side aisles, which have beamed and trussed ceilings, are divided into three separate bays by two transversal arches. The bay furthest from the façade houses the choir. Construction work is likely to have begun with the crypt, continuing down the side aisles to embrace the old paleochristian church, where services could thus continue to be held. The paleochristian church was roughly the same width as today's nave and stretched from the façade to the choir of the present basilica. Finally, the old church was demolished, the nave itself was built and the marble floor was laid.

The decoration of the façade is commonly thought to reflect the same three phases. The lower register with six columns carrying five round arches is thought to belong to the first phase, the higher register covering the upper part of the nave to the second, and the triangular pediment crowning the façade to the third.

Yet, as we shall see, the façade was unquestionably planned around a single project based on stringent geometric and symbolic consistency, which appears to contradict the hypothesis of its construction at such different and distant times.

2. THE SYMBOLISM OF THE CENTRE OF THE WORLD AND THE LADDER TO HEAVEN

The vision of the world in ancient religious sentiment was structured around the concept of a matching heaven and earth. People considered that invisible currents and permanently open passageways existed between them. One of the most widespread symbols for indicating these passageways was the *Cosmic Tree* or the *Tree of Life* which, shared by all cultures with different imagery, represented the relationship between heaven and earth, between God and man. This tree was situated in the legendary "*navel*" of the world, the centre of the cosmos, recognisable in every place that a community identified as being imbued with particular holiness, a fully-fledged gateway opening onto heaven, like the ladder which Jacob saw rising out of the stony ground of Bethel in his dream, with Angels going up and down the steps[4][5]. *Jacob's Ladder* is the symbol most frequently used in ancient mysticism to indicate the Door to Heaven. Rabbinic meditation, so attentive to the hidden meanings in every word of Scripture, pondered at some length the reason why Jacob saw angels first going up and then coming down. Given that angels live in heaven, it would be more logical if they first descended and then ascended. The explanation that the Rabbinic tradition managed to come up with is simple: the angels Jacob saw in his dream are in actual fact

[4] "*All eastern civilisations... know a boundless number of Centres. Or rather, each one of these centres is considered, nay, is literally named the Centre of the World. The area in question is a sacred space determined by a hierophany, in other words a space that has been ritually constructed rather than a profane, homogeneous, geometric space, thus there is no problem whatsoever with there being a plurality of Centres of the Earth in one region...*", "Immagini e simboli" Milan, Jaca Book, 1980, p. 40; see also "Cosmologia ed Alchimia babilonesi" Florence, Sansoni, 1992; "Arti del metallo e alchimia" Turin, Boringhieri, 1987; "Mefistotele e l'androgine" Rome, Mediterranee, 1971.

[5] "Immagini e simboli" Milan, Jaca Book, 1980, p. 45.

those who, having achieved the spiritualisation of the body through contemplation, can attain ecstasy. Interiorly transfigured, they are then led back down to earth[6]. This interpretation was transferred into Christian mysticism very early on in its history. Just as the stone of Bethel could become a House of God because Jacob had already identified the place on which it rose as being a door to heaven, in other words a place that was sacred by its very nature, so sacred buildings had to be situated at the confluence of those opposing, invisible currents whose harmonious combination and exaltation appear to facilitate the thin body's ascension towards the celestial land, in other words the ascent up Jacob's Ladder to the vision of God. It was thus appropriate that, as in some kind of spiritual alchemy, temples should be built in special places where the earth's vibrations emerge with greater intensity, and that their walls of worked stone, acting like a resonance chamber, should set them in tune with the vibrations of heaven.

Thus, if a sacred building was to achieve full correspondence between the earth and heaven, and consequently to open up the passage seen by Jacob, it had to meet three esoteric conditions:

1. It had to be situated at one of the earth's most sensitive points, those points which by their very nature appear to lie at the confluence of the three worlds.

2. It had to be built in the image of the cosmos and in accordance with its laws, in other words in accordance with the mathematical-cum-musical ratios that form the bricks with which primeval Wisdom built the universe.

3. It had to be oriented in such a way that it was in direct relation to heaven, which had to enter it on the sun's rays.

Let us take a closer look at these three aspects, starting with the first.

[6] *"A close reading of the text reveals that the angels travelled up and then down the ladder. The succession is wrong: if the angels are in heaven, should the order not be reversed, i.e. did they not travel down and then up? Rabbinic tradition offers several possible explanations... The angels were not in heaven at all, they lived on earth and they were normal human beings"*, Rabbi Lawrence Kushner "God Was in This Place & I, I Did Not Know" (seven commentaries on Genesis, 28:16) Woodstock, Jewish Lights Publishing, 1993, pp. 12-13.

3. THIN PLACES

The mystic and the gnostic initiated into the mysteries shared a common purpose, which was to free the spirit from the constraint of the physical body and to allow it to unite with God from Whom it drew its origin, not only after the death of the body but while it still inhabited that body, through what Pico della Mirandola, echoing in this the kabbalists and such mystics as St. Bernard of Clairvaux, called the *mors osculi*, or death in a kiss; in other words, ecstasy. The mystic who had achieved knowledge of God through ecstasy and the control of his own body and mind elevated himself to God's level and united with God, then returned to earth and proceeded to dispense the perfume of paradise around his person.

It is possible that there are places where deep energy helps to distance the spirit from the body, particularly sensitive places that constitute a gateway to heaven by the very nature of the forces that pass through them. We may calls such areas "thin places" by analogy with the thin centres that Oriental mysticism identifies in the human body. In yoga there are seven energy centres known as *chakra*, or *wheels*, paralleling the spinal column. If we focus our mind and breathing on each of these, *kundalini*, the cosmic energy that flows up the spinal column to the brain, is awakened a little at a time. *Kundalini* is known as the "serpent power", with a symbol that Western esotericism has associated with the earthforce that emerges from the depths of the earth.

The Jewish tradition acknowledges some of these thin centres. They were activated in religious terms by a laying on of hands[7]. Thus we also

[7] "*In the Bible one can detect an attention to parts of the body that are reminiscent of thin places, channels of spiritual opening that give man the opportunity to achieve a deeper vision of reality and thus to increase his awareness as he participates in it*" Alberto Camici, Alessandro Orlandi "La fonte e il cuore: cristianesimo e iniziazione" Rome, Edizioni Appunti di Viaggio", 1998, p. 54.

find Christian ritual showing a certain interest in the higher *chakrai*: "*In Baptism the sign of the cross is drawn on the forehead, the heart and the nape of the neck; in Confirmation the hand is laid and the cross anointed using chrysm first on the top of the head and then on the forehead. The space between the eyebrows has always been identified as the seat of enlightenment... What we're looking at here is a series of gestures that reveal an awareness of the thin centres of the human body even in early Christianity*"[8]. *Hesychasm*, an ascetic practice of the Eastern Church that betrays clear affinities with the *dihkr*, the rhythmic invocation of the name of God in Islamic tradition, and with the discipline of yoga, associates the repetitive uttering of the name of Jesus with breathing through the *chakra* of the heart and the navel.

According to the concept of the sacred handed down to us from ancient times, the world and man are alike, sharing the same nature and permeated by the same vital energy. The world is a living thing with its own soul, Plato's *Anima Mundi*[9].

The Mazdean Avesta tells us that the world is an "angel": "*We celebrate this liturgy in honour of the Earth, which is an Angel*"[10].

So if thin centres exist in man, then the angel of the world must have similar centres, and it is through these that the earth breathes and condenses the universal spirit. The world's thin centres probably number far more than the seven that we know in man, but Jerusalem is unquestionably the first of them.

If a sacred building is erected in one of these places, which are located by their nature at the confluence of the two worlds, it can become a blessed passageway, a Door to Heaven. It is a well-known fact that Benedictine and Cistercian abbeys were symbolically held to be Jacob's ladders, indeed they often bore its name, and that Cistercian abbeys were not founded in chance locations but in places that the abbot identified intuitively and by heavenly inspiration: "*Numerous Cistercian*

[8] Ibidem, p. 55.

[9] "*The soul, interfused everywhere from the centre* (of the earth) *to the circumference of heaven, of which also she is the external envelopment, herself turning in herself, began a divine beginning of never ceasing and rational life enduring throughout all time.*" Plato "*Timaeus*" translated by Benjamin Jowett, Forgotten Books, 2008, p. 22.

[10] Quoted by Henry Corbin in his "Spiritual Body & Celestial Earth: From Mazdean Iran to Shi'ite Iran", Princeton University Press, 1977, p. 35.

monasteries moved ten or twenty years after their foundation, like Clair-vaux, or like Le Thoronet, which was first founded at Floriège, in search of more appropriate sites miraculously indicated to the abbot in a dream or a vision"[11]. It was not simply a matter of choosing a spot that was healthier or better suited to monastic logistics. The reference to the abbot's vision tends to hint at a search for a thin place. This was proba-bly identified through some form of psychic power, of ultrasensorial sen-sitivity, which monastic prayer, fasting and solitude either heightened or brought out.

The thin places are centres of the world, its navels, and they link the waters below the earth with the waters of the cosmos. In fact, the pres-ence of subterranean waters appears to be a regular feature of such places[12]. In the vision of Ezekiel, a raging torrent steadily swelling as it brings life and fertility to the earth gushes from beneath the eastern side of the Temple. Symbolism is undoubtedly intended here because water is the allegory of Wisdom, which renews human nature and allows it to be reborn in union with God; yet in the thin places it also seems to find physical confirmation. Under every one of the earth's *navels*, water flows fast and freely, often gushing to the surface in copious springs. In Book V of the Histories, Tacitus speaks of a *fons perennis aquae* that rises inside the perimeter of the Temple of Jerusalem. Chartres cathedral was built on a bend in a broad underground river, but the master masons who built it took care to dig another 14 artificial channels below the foun-dations of the choir. These channels flowed into the river at regular in-tervals, in proportion to the architecture above them. A similar arrange-ment has been discovered at Santiago de Compostela, while also in the

[11] Georges Duby "Saint Bernard et l'art cistercien" Paris, Flammarion, 1979, pp. 120-121.

[12] "*In Babylon the link between the Earth and the nether regions was activated because the city had been founded on* bab-apsi, *the "gate of apsu" and* apsu *designates the waters of chaos before the Creation. We find the same tradition among the Jews. The rock of Jerusalem penetrated deep into the underground waters* (tehom). *It says in the Mishna that the temple is sited exactly above the* tehom *(the Jewish equivalent of* apsu). *And, just as in Babylon there was the gate of apsu, so the rock of temple, the Temple Mount in Jerusalem, sealed the mouth of the tehom. We find similar concepts in the Indo-European world. For the Romans, for instance, the* mundus *is the place where the nether regions meet the earthly world. The Italic temple was the area where the upper (divine), earthly and subterranean worlds intersected...*" Mircea Eliade "Images and Symbols", *op. cit.*, pp. 40-41.

crypt at Chartres a well of Celtic origin whose water was held to be miraculous meets the water table 37 m below floor level, and it is significant that the cathedral vault rises to exactly the same height above floor level[13]. It is common knowledge that the hill of San Miniato is riddled with water veins, and indeed they have caused frequent problems in connection with the stability of the hillside. The Renaissance church of San Salvatore, situated only a short distance away, has suffered from cracks and subsidence over the centuries, while the basilica of San Miniato, erected on the crest of the hill, on the precise spot where the energies seem to balance out, has always remained solid and insensible to the hill's tremors[14]. Thus it is no mere coincidence that the summit of the hill of San Miniato has been considered sacred since ancient times.

Until not so long ago, the idea of the existence of thin places would have brought a smile to most people's lips. Today, however, we are aware of the fact that we live inside a huge electromagnetic field generated by the movements of the planet's incandescent core and by the constant exchange of electric circuits between the earth and the rest of the universe, where every single body vibrates and emits energy. We have also taken on board the existence and the intensity of earthforces and their influence on mankind, learning to use gaussmeters to calculate their strength.

A particular concentration of energy seems to be present in limited and clearly defined areas inside the so-called Hartmann Net, named after Dr. Ernst Hartmann from the University of Heidelberg, who first posited its existence in the 1980s. According to Hartmann, earthforces or radiations encase the entire planet in a kind of invisible net. This huge grid is made up of bands approximately 21 cm wide set at a distance of 2 m from one another on the north-south axis and 2.5 m from each other on the east-west axis. Where they intersect, they constitute powerful alignments of strength which produce knots known as Hartmann Knots. The earth's radiation unleashes its full force at these knots, having a profound effect on living beings. The presence of fault lines or underground

[13] Cf. Blanche Merz "I luoghi alti. Le sconosciute energie cosmotelluriche e la loro influenza sulla vita umana" Milano, Sugarco, 1986, pp. 100-119; and Louis Charpentier "I misteri della cattedrale di Chartres" Torino, Arcana Editrice, 1972.

[14] Renzo Manetti "Il dissesto idrogeologico del Monte alle Croci nelle carte del Poggi" in "Bollettino Tecnico", Jan-Feb 1981, pp. 3-5.

water courses appears to increase the amount of energy radiated by the knots in the net.

Another grid, known as the Curry Grid, is induced by energy from the cosmos and consists bands 75 cm in depth, set 3.5 m from one another in a northeast-southwest direction.

The earth's energy acts as the planet's negative pole while cosmic energy is its positive pole.

The ancients were aware of the existence of these currents of energy, and of the fact that the currents converge with greater strength in certain places, triggering psychic effects capable of sharpening the higher sensory faculties even to the point of causing a vision of the transcendent world. Menhirs, or standing stones, were probably erected in such a way as to direct the earth's energy towards its meeting point with the energy of the cosmos, while dolmens, two upright stones covered by a large horizontal slab of stone, were sacred chambers within which an intense field of forces was allegedly focused. Harmonious architecture reflecting the magic inherent in musical proportions appears to accentuate the effect of these currents. The vibration of the earth struck by underground waters may facilitate the rupture of the barriers between the various levels of being and allow the thin body to wander through the gardens of the spiritual world in ecstasy, savouring the fullness of Eden.

So the heart of a piece of sacred architecture built in accordance with the laws of the cosmos is saturated with opposing energies in harmonious correspondence with each other, like some kind of alchemical cup in which the quintessence is condensed from a union of opposites. It is no mere coincidence that a Cup, the chalice of spiritual transmutation, the Grail sought by Arthur's knights on a pilgrimage that lasted a whole lifetime, should have been depicted on the Romanesque façade of San Miniato, as it so often is in medieval churches.

4. Cosmic Symbols

The three worlds that constitute the cosmos, whose convergence determines the opening of the Door to Heaven, come together in the sacred space of the temple[15]. In San Miniato, the tripartite form of the basilica seems to be an attempt to make the convergence of the cosmic levels explicit. The crypt sinks its roots into the lower regions of mother earth, whose womb holds the waters of regeneration; the nave runs along the earth's surface, its path akin to that of the soul through the cosmos; and the chancel climbs heavenwards, ending in the embrace of the apse, where the figure of Christ is seated in the celestial vault, the home of the higher nourishing waters.

While not all temples in antiquity were places of worship, all of them—Babylonian ziggurats, Egyptian temples, megalithic stone circles, imperial mausolea and Mithraic caves—were nevertheless conceived as models of the cosmos. From the very first days of the era of Constantine, this was matched by an explicit effort to endow the architecture of Christian churches with a cosmic nature too, carrying on an imperial Roman tradition. Philo of Alexandria said: *"Those preparing a temple made by hands for the Father and Ruler of the universe, must take essences similar to those of which He made the universe itself"*[16]. And Titus Flavius Josephus wrote: *"The raison d'être of each of the objects in the Temple is to conjure up and to depict the Cosmos"*[17].

[15] *"In cultures that have the conception of three cosmic regions - Heaven, Earth and Hell - the "centre" constitutes the point of intersection of those regions. It is here that the break-through onto another plane is possible and, at the same time, communication between the three regions... Hell, the centre of the earth and the "door" of Heaven are all to be found, then, upon the same axis, and it is along this axis that the passage from one cosmic level to another is effected..."* Mircea Eliade "Images and Symbols", *op. cit.*, p. 40.

[16] Philo of Alexandria "A Treatise on the Life of Moses, that is to say, On the Theology and Prophetic Office of Moses" in "The Works of Philo Judæus, the contemporary of Josephus, translated from the Greek by C. D. Yonge, Vol. III" London, Henry G. Bohn, 1855.

[17] Flavius Josephus "Ante Judaeos", III:7,7.

Constantine's rebuilding of the Holy Sepulchre in Jerusalem, with the construction of the cosmic rotunda known as the *Anastasis*, was conceived as an image of the celestial Jerusalem and erected in the heart of the earthly Jerusalem, in other words, at the origin of the axis linking the two regions. All three "religions of the Book" consider this to be the first thin centre of all, the sacred place where heaven and earth meet.

The Church's cosmic symbolism found its most complete codification between the 6th and 7th centuries in a way that was to enjoy widespread dissemination: Cosmas Indicopleustes, in his *Topographia Christiana*, mooted a construction comprising a cube, which Plato had earlier likened to the earth in his *Timaeus*, surmounted by a hemispherical dome symbolising the sky. The cathedral of Edessa, in Syria, was built in accordance with this model, and St. Maximus the Confessor was to say of it in a famous hymn: *"O Essence which residest in the holy Temple, whose glory comes from Thee by nature, Grant me the grace of the Ghost to speak of the Temple of Edessa... it is an admirable thing that in its smallness it should resemble the great world... Its high dome is comparable to the heaven of heavens... Its great, splendid arches represent the four sides of the world... Its marble is like the Image not made by human hand, and its walls are harmoniously covered therewith. All polished and white, [this marble] is so shining that it gathers light within itself like the sun... Exalted are the mysteries of this Temple concerning the heavens and the earth...".*

Justinian had the Hagia Sophia in Constantinople built to the same model, a summary of the entire universe on an unusual scale which was unparalleled for many centuries. It is significant that both cathedrals, Edessa and Constantinople, were dedicated to Wisdom, the primaeval creative force that was by God's side as the architect of the universe before time began: *"When he appointed the foundations of the earth, then I was by him, as a master workman"*[18]—the Wisdom which the Book of Proverbs calls a *Tree of Life*[19], in other words the link between heaven and earth.

[18] Proverbs, 8:29-30.

[19] "She is a tree of life to them that lay hold on her: and he that shall retain her is blessed", Proverbs, 3:18.

5. Solar Symbols

The symbolic association of the world of the divine with light and the sun sounds obvious to us today, and it comes as no surprise to discover that the earliest Christian churches were built around a highly developed theology of light. But this tradition, while ancestral, is not shared by all cultures, thus we may well wonder where Christianity borrowed it from.

In traditional thought, the sun represented the prime mover of the cosmos and for that reason it was often associated with the supreme divinity. The theme of light is one of the most recurrent themes even in such early works as the Pyramid Texts. Ra was the divine light and Pharaoh was his image. Plutarch wrote that Osiris was identified with the sun[20]. Persian theology, too, linked light and brightness with the good God, Ahura Mazda, and darkness with his foe, the principle of evil[21]. The god Mithras, whose cult spread throughout the empire between the 2nd and 3rd centuries A.D., was a sun god depicted wearing a crown with the sun's rays emanating from it; and like Pharoah with Ra, so too the Persian Great King was the Sun's living image. This identification of the monarch with the sun god was adopted by the Hellenistic sovereigns and

[20] *"They clothe his statues in a flame-coloured garment, since they regard the Sun as the body of the Good Principle, the visible form of the Intelligible Being... In the sacred hymns of Osiris they call upon him who is hidden in the arms of the Sun... They think that by means of all these they supplicate and serve the Sun... There are some who without reservation assert that Osiris is the Sun."* Plutarch "Isis and Osiris" LI - LII, trans. Frank Cole Babbitt, Loeb Classical Library edition, 1936.

[21] *"Persian speculation developed the antagonism between Light and Darkness to a level that cannot be found elsewhere, referring to Light not simply as God the good creator, Ahura Mazda, but also the very essence of creation and light, and above all the spirit and spiritual energy"* Mircea Eliade "Mephistopheles and the Androgyne; studies in religious myth and symbol" New York, Sheed & Ward, 1965, p. 45.

entered the cult of the Roman emperors. This symbolism can clearly be seen in the adoption of a circular plan in the architecture of their palaces, and especially of their mausoleums. Even Leon Battista Alberti recognised the central plan as denoting a temple dedicated to the sun in the classical era[22].

The Persians thought that a bright star would herald the birth of the *Cosmocrator*, the Saviour, which would take place in a cave over which the star would halt, taking on the shape of a column of light. The tradition of Matthew and of the *Protoevangelium* of James harks back to this belief to prove Jesus's messianic role, because the Mithraic cult was Christianity's strongest antagonist, sharing with it its strong moral thrust and its notions of the immortality of the soul, of a single god, the father and creator, and its expectation of the coming of a saviour. The Church Fathers accused the adepts of the Mithraic religion of using similar rituals to those of the Christians, like the offering of bread and wine, but it is more likely that both religions, as they developed and got organised in imperial Rome, borrowed rituals and symbols from the Persian east. In their effort to attract converts, the early Christians needed to prove that the saviour whom even the cults originating in Persia were awaiting was in fact none other than Jesus Christ, and thus they needed to make sure that the rich solar and cosmic symbolism, which by that time had totally permeated religion in late imperial Rome, accrued to the figure of Jesus.

In parallel with the spread of the cult of Mithras, several neo-Platonic and neo-Pythagorean philosophers in Syria, where the Greek, Persian and Jewish cultural strains met and mingled, were developing a theology of light and of the sun that was spreading equally rapidly throughout the empire. Their number included Poseidonius and Numenius, both of whom were born in Apamea, a city in Syria located between Antioch and Edessa, which was a major hub on the caravan routes and a fertile centre for the spread of ideas. As we have seen, most of the Christian community in Florence originally hailed from there. These philosophers had developed the idea of a single God, the prime mover of the cosmos, and all of the traditional gods were merely emanations of this single Being,

[22] Leon Battista Alberti "De Re Ædificatoria. On the art of building in ten books" VII, 3:114; (translated by Joseph Rykwert, Neil Leach, and Robert Tavernor). Cambridge, Mass.: MIT Press, 1988.

whom they identified with the sun. Between the 2nd and 3rd centuries, the cult of the sun, whose earthly personification was the deified emperor, had ended up absorbing the traditional cults in the various provinces of the empire, merging them into a syncretic monotheism that aimed to supplant all other religions and become the empire's sole religion; it *"was supposed to endow the empire, of which every free man was by this date a citizen, with the value of a religious community too, a community held together by a common moral code and by a common form of worship that did not totally abolish the ancient, traditional cults proper to the empire's individual ethnic groups"*[23]. This doctrine is already clearly evident in the Pantheon, which Hadrian had built in the 2nd century as an image of the cosmos, its dome open to the sky in order to allow the sun's rays to cross the whole building and circumscribe its ground plan. The Emperor Aurelian, for his part, introduced the worship of the Sol Invictus into 3rd century Rome, linking it to the cult of the imperial family[24].

Rome's religious tolerance attempted to absorb Christianity into this religious system built around the sun and the imperial family, but in the end it was Christianity that prevailed and absorbed it. Thus the sun became the symbol of Christ: *"All of the great sun myths were recuperated and adapted to fit Christ... The sun is seen as the one who ordains the cosmos and inspires light... Christ is compared to the sun. He is at the same time both the sun of salvation (sol salutis) and the unconquered sun (sol invictus)..."*[25]. Christianity adopted the sun festivities, the Christians of the West deciding symbolically to commemorate Jesus's birth at around the time of the winter solstice on 25 December, the birthday of Mithras and of the Sun; Christmas spread more gradually to the East, where it was celebrated on 6 January in Alexandria, here too replacing a sun festival of Egyptian origin. In the 5th century carved doors of Santa Sabina in Rome, the wise men adoring the Christ Child wear the Phrygian cap of Mithraic initiates, clearly alluding to Christianity's victory over its rival cult but also to the identification of Jesus with *Saoshyant*, the Mazdean saviour.

[23] Alberto Pincherle "Introduzione al Cristianesimo antico" Bari, Laterza, 1994, p. 135.

[24] *"Adored in a splendid temple by pontiffs enjoying the same status as the early Roman pontifex and honoured with magnificent games every four years,* Sol invictus, *too, was raised up to the highest place in the divine hierarchy and became the special guardian of the emperors and of the empire"*, Franz Cumont "Le religioni orientali nel paganesimo romano" Bari, Laterza, 1967, p. 143.

[25] Marie-Madeleine Davy "Initiation à la symbolique romane" Flammarion, Champs, 1.982.

The association of Christ with the sun is found in the Gospels, more especially in John and Matthew (whom we have already noted was the only evangelist to recount the story of the wise men), using the luminous symbolism of Persian origin connected with it. In the prologue to the Gospel of John, the Word is Light: *"That was the true Light, which lighteth every man that cometh into the world"*[26]. Matthew lays great emphasis on the episode of the transfiguration of Christ on Mount Tabor, where he explicitly compares Christ to the sun: *"And [He] was transfigured before them: and His face did shine as the sun, and His raiment was white as the light"*[27].

In the Jewish biblical tradition, light is created by God and is thus distinct from Him: *"And God said, Let there be light: and there was light"* (Genesis 1:3); this means that it also contains images associating the manifestation of God with the darkness, night or twilight[28], even calling Him *shade*.[29] The image of the Glory of God hidden in a cloud is also fairly common[30].

The Jewish tradition also contains light-related metaphors in the Book of Wisdom, where wisdom is called the *"brightness of eternal light...more beautiful than the sun"*[31]. But the wisdom writings were composed after the Pentateuch (the Torah), in other words after the Babylonian captivity, and they were clearly influenced by Persian theology. The Book of Wisdom, in particular, was written during the Jewish Hellenistic period. Thus the identification of light with the world of the divine in the Jewish tradition appears to have been introduced through the influence of the Mazdean religion and of the Hellenistic Κοινή.

In the Jewish Kabbalah, God and his emanations, the ten Sephirot, are unequivocally identified with light and the mystic experience with enlightenment, but this esoteric Jewish doctrine was spawned by the com-

[26] John, 1:9.

[27] Matthew, 17:1.

[28] Cf. Henri Charles Puech "En quête de la gnose", Paris, Gallimard, 1978.

[29] "The Lord is thy shade upon thy right hand", Psalm, 121:5. Cf. in this connection, Moshe Idel "Kabbalah: New Perspectives" Yale University Press, 1990, p. 166 ff.

[30] "The glory of the Lord appeared in the cloud", Exodus, 16:10; "A cloud filled the house of the Lord... for the glory of the Lord had filled the house of the Lord", 1 Kings, 8:10; "And the cloud filled the temple, and the brightness of the Lord's glory filled the courtyard", Ezekiel, 10:4.

[31] Wisdom, 7:26 and 7:29.

plex universe of Gnosis[32]. The identification of the divinity with light is always explicit in the gnostic texts. The Gospel of Thomas states that God is light and that within every man there is an image of light. In other gnostic texts Jesus calls Himself the image of the Light of the Father. In the Apocryphal Acts of John, the Supreme Being is identified with pure light: *"He is the immeasurable, purified, holy, clear, indescribable light, perfect in its everlasting eternity"*[33].

The Hermetic texts, which conjugate gnosis with Egyptian and Persian theology, frequently reaffirm the divine nature of light. Pymander, the *Noῆς*, tells Hermes: *"I am that Light, the Mind [Noῆς], thy God... I beheld in my mind the Light that is innumerable, and the truly indefinite ornament or world"*[34].

Neo-Platonic and gnostic influences also form the basis of light-related mysticism in Islam, the most significant expression of which is to be found in Sufism. Occupying Persia and Syria, where Platonism had merged with Persian doctrines in fertile syncretism, Islam was won over by the local culture. Indeed after an initial bout of persecution, Zoroastrianism, just like Christianity and Judaism, was acknowledged by the Arab conquerors as being a "religion of the Book" and therefore tolerated. In addition to this, the neo-Platonic philosophers of the School of Athens, hounded out by Justinian in the 6th century, had sought refuge in Persia and been welcomed there with open arms.

The symbolic identification of Christ with the sun and with light, conveyed not only through the Gospels but also through the Second Letter of Paul to the Corinthians[35], was endorsed by those Church Fathers who sought to reconcile Platonic philosophy with Christian theology: Saint

[32] See Moshe Idel "L'esperienza mistica in Abraham Abulafia" Milan, Jaca Book, 1992, p. 102 ff. For the gnostic origin of the Kabbalah, see the many works by Gershom Scholem, including "On the Kabbalah and its Symbolism" Schocken, New York, 1996 and "Major Trends in Jewish Mysticism" Schocken, New York, 1995.

[33] Cited in "La Gnosi e il mondo. Raccolta di testi gnostici" edited by Luigi Moraldi, Milan, Tea, 1988, p. 6.

[34] "The Divine Pymander of Hermes Trismegistus" tr. John Everard, Wizard's Bookshelf, San Diego, 1994.

[35] 2 Cor 4,4 - 6 *"... lest the light of the glorious gospel of Christ, who is the image of God, should shine unto them... For God, who commanded the light to shine out of darkness, hath shined in our hearts, to give the light of the knowledge of the glory of God in the face of Jesus Christ"*.

Justin Martyr, in the 2nd century A.D., considered Platonism to be a path leading to an understanding of the eternal truths revealed by Christ; St. Clement of Alexandria, in the 3rd century A.D., argued that God, like the sun, is the heart of the cosmos; Origen, the greatest and most controversial of all Christian theologians and, like Plotinus, probably a pupil of Platonist teacher Ammonius Saccas, considered the deepest truths in holy scripture to be incomprehensible to the ignorant and thus it is necessary to conceal them behind esoteric symbols[36]; and lastly, St. Gregory of Nyssa, a follower of Origen and a neo-Platonist. Of the greatest importance among the early fathers on account of the impact he had on medieval thought was Augustine of Hippo, who had absorbed neo-Platonic thought and its adaptation to Christianity by Gaius Marius Victorinus in Milan, and who had converted for that very reason. In Christianising the Platonic doctrine of knowledge, Augustine described it as an interior enlightenment induced by divine grace. Augustine agreed with St. Justin Martyr that an anticipation of the truth revealed by Christ could be found in the pagan philosophers.

Dionysius the Areopagite, or rather the unknown 5th century writer who was identified with St. Paul's disciple in the Middle Ages, also succeeded in conjugating neo-Platonism with Christianity. Indeed it is no mere coincidence that he came from the same Syrian cultural background that we have already seen at work forging an effective syncretism between Platonism and Persian theology. Dionysius states that the sun is the visible and symbolic image of the unknowable God: *"For the light is from the Good, and an image of the Goodness, wherefore also the Good is celebrated under the name of Light; as in a portrait the original is manifested... so, too, the brilliant likeness of the Divine Goodness, this our great sun, wholly bright and ever luminous, as a most distant echo of the Good, both enlightens whatever is capable of participating in it, and possesses the light in the highest degree of purity, unfolding to the visible universe, above and beneath, the splendours of its own rays..."*[37].

[36] Cf. Henry Chadwick "Early Christian Thought and the Classical Tradition", Oxford, Oxford University Press, 1984.

[37] "On Divine Names" in "Early Church Fathers - Additional Texts" edited by Roger Pearse for www.ccel.org/.

Christian mystics also frequently identified God with light and ecstatic union with enlightenment. St. Bernard, a master of the Cistercian order, developed a theology of light that lay at the root of Cistercian church architecture: *"God is Light!"*[38] Light from the large windows in the east-facing chancel slides off the bare walls of unadorned Cistercian abbey churches. St. Bernard himself described Paradise as a luminous ocean: *"What will happen when souls are separated from their bodies? We believe that they will be plunged into a vast ocean of eternal light and of luminous eternity"*[39]. This, incidentally, is the very same vision as the river of light that welcomes Dante, a disciple of St. Bernard and a student of Dionysius, into Paradise.

The identification of the Word with the Sun meant that the east, the origin of the rising sun's rays, became the symbol of Parousia, the second coming of Christ on Judgment Day. The Gospel of Matthew tells us: *"For as the lightning cometh out of the east, and shineth even unto the west; so shall also the coming of the Son of man be"*[40]. The word orientation, literally the organisation and reference of earthly space through the east, shows the extent to which the symbolism of the rising sun has become rooted in our Western Christian culture. The orientation of prayer, which was practised by the Egyptians and the Persians, was a logical consequence of the symbolism of the east. Tertullian urged people to pray facing the east, and St. Augustine also mentions such a custom; according to Eusebius of Alexandria the Christians prayed towards the east until at least the 5th century, which is why a Christian church is traditionally entered through its west front while the apse or chancel, towards which the prayers of the faithful are addressed, lies at its east end.

Yet we should remember that the sun rises in the geographic east only at the time of the equinox. For the rest of the year it shifts to such a degree that it coincides with the northeast at the summer solstice and with the south east at the winter solstice. The basilica of San Miniato, like many other traditional churches even richer in sacred symbolism, is

[38] Sermones in Cantica Canticorum, XXVI. The results of Manuela Incerti's fascinating research into this aspect of Cistercian architecture can be found in her book "Il disegno della luce nell'architettura cistercense", Florence, Edizioni Certosa Cultura, 1999.

[39] Cited in Marie-Madeleine Davy "Initiation à la symbolique romane", *op. cit.*

[40] Matthew, 24:27.

"oriented" towards the southeast because that is the direction from which the sun's rays rise at the time of the year when Christians celebrate the birth of Christ, the Sol Invictus. The same "orientation" can be found in the great celestial church of Hagia Sophia in Byzantium which, despite its basically central plan, has a small apse opposite the entrance facing southeast, and containing a painting which I believe represents the esoteric icon of Holy Wisdom. Thus the main entrance in Santa Sophia, like that in the basilica of San Miniato, faces northwest.

6. THE SACRED NUMBER

Iamblichus states that the sun's number is five because it generates light through its circular motion: if it is raised to a power, it always ends with itself: *"The number 5 is, of all numbers, the one that best comprehends the phenomena of cosmic nature. For truly we often state that the entire universe appears complete and contained in the number 10, and rooted in the number 1, and that it receives movement from the number 2, and its nature as a living being from the number 5... The number 5... since it moves in a circle and produces light, ... is also called light..."*[41].

In the zodiacs that adorn the floors of San Miniato and the Baptistry of San Giovanni, the signs are set around an image of the sun which, unmoving in the centre, represents the divine element that is the origin of all generation and the mover of all cosmic rotation; that is, the Word.

Plutarch, a priest at Delphi, the navel of the world in Greek culture, writing between the 1st and 2nd centuries A.D., very effectively described the mystic significance of the number 5 and of the special right-angled triangle whose hypotenuse is equal to 5: *"The better and more divine nature consists of three parts: the conceptual, the material, and that which is formed from these, which the Greeks call the cosmos, the world. Plato is wont to give to the conceptual the name of idea, example, or father, and to the material the name of mother or nurse, or seat and place of generation, and to that which results from both the name of offspring or generation. One might conjecture that the Egyptians hold in high honour the most beautiful of the triangles, since they liken the **nature of the Universe** most closely to it, as Plato does... This triangle has its upright of three units, its base of four, and its hypotenuse of five, such that its*

[41] Iamblichus "Theologumena Arithmeticæ".

square is equal to the sum of the squares of the other two sides containing it. The upright, therefore, may be likened to the male, the base to the female, and the hypotenuse to the child of both, and so Osiris may be regarded as the origin, Isis as the recipient, and Horus as the perfected result. Three is the first perfect odd number; four is a square built on the even number two; but five is in some ways like to its father, and in some ways like to its mother, being made up of three and two; also, we should remember that the All (Πάντα) derives its name from the Five (πέντε)"[42]. Generated by the number 3 through union with the receiving principle or recipient, be it the number 2 or its power, in other words the number 4, the number 5 is thus in Plutarch's view the number of primal man, the Adam Kadmon of the Kabbalah and of the manifestation of the divine in creation.

The number five in sacred numerology is also the symbol of the spiritual quintessence and of man rooted in the spirit. Space-time is regulated by the number four, which is present in the directions of space, in the elements that make up the cosmos (fire, air, water and earth), in the seasons and in the week, which is one-fourth of the lunar cycle. The ancients had noticed that the human figure, on the other hand, appears to hinge on the number five: five are man's senses, five are the fingers which give him mastery over the divine number, and five parts (the legs, the arms and the head) emerge from the torso; this appeared to demonstrate that man has been given a fifth element, the quintessence, which allows him to partake of divine nature itself.

The number five is closely linked with the golden ratio, through the pentagon and the dodecahedron that is derived from it. The golden ratio is an incommensurable ratio which ancient tradition associated with the sacred; Plato in the *Timaeus* argued that it was the ratio with which God had designed the cosmos: *"There was yet a fifth combination which God used in the delineation of the universe"*[43].

The ratio between two numbers is known as golden when it is equal to the ratio between their sum and the greater of the two: $a : b = (a + b) : b$.

[42] Plutarch "Isis and Osiris", tr. Frank Cole Babbit for Vol. V of the Loeb Classical Library, Harvard University Press, 1936, pp. 135-137.

[43] Plato "*Timaeus*", *op. cit.*

Arithmetically, this gives us the irrational number $\frac{\sqrt{5}+1}{2}$.

Geometrically, it is easy to see and corresponds to the ratio between the diagonal and the side of a regular pentagon. The method used for drawing a pentagon with a set square and compass begins precisely with the construction of a golden section. We should note that when we map out all the diagonals of the pentagon, they intersect to form segments that are in the golden ratio to one another: this is how to draw the five-point star inscribed in a circle, the sacred golden pentagram which the Pythagoreans considered to be a symbol of harmony between man and the cosmos, while in the Renaissance it was held to symbolise the celestial energy present in man. In its guise as a pentacle, the five-point star was considered to be the key to opening the mysteries of the universe and focusing their energies in a magician's gestures.

Thus we also find the golden ratio on the pentagonal faces of the dodecahedron, which the Platonists associated with the fifth essence, the quintessence, the unchanging and universal ether, and frequently also with the zodiac: *"God availed himself of the dodecahedron for the universe: that is why we see in the heavens 12 signs within the circle of the zodiac, and each one of these is divided into 30 parts; and as in the dodecahedron, which is made up of 12 pentagons each divided into 5 triangles further comprising 6 triangles each, thus giving us 360 triangles altogether, so also the zodiac contains the same number of parts"*[44]. Iamblichus too, writing in the 4th century A.D., tells us that: *"There are five solid figures whose sides and angles are equal for each face: the tetrahedron or pyramid, the octahedron, the icosahedron, the cube or hexahedron and the dodecahedron. Plato says that these are the figures of fire, air, water, earth and the universe respectively"*[45].

To find the golden section of a segment, in other words its division into two parts in a golden ratio to one another, the procedure is simple: taking a segment, we draw a circumference whose diameter is equal to its length and tangential to the segment at one end; we now join the other end to the centre of the circumference; the golden section of the segment is the external part of the secant (fig. 2).

[44] Albinus "Didascalicus" XIII, 2, cit. in Plato *"Timaeus"*, *op. cit.*, p. IV Appendix.
[45] Iamblichus, *op. cit.*

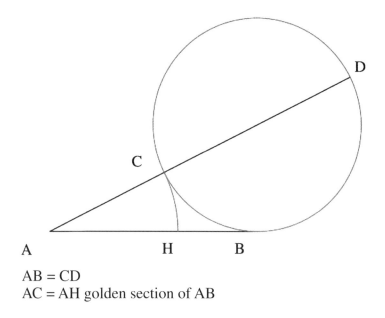

AB = CD
AC = AH golden section of AB

Fig. 2 - *Costruction of the golden section*

A golden rectangle can easily be drawn from an initial square: placing the needle of a compass on the midpoint of one of its sides, we draw the arc of a circle whose origin is on any one of the opposite two vertices; as the arc of the circles meets the extension of the side of the square that we used as our centre, it determines the larger base of the golden rectangle, whose smaller base coincides with the side of the original square.

The golden number has an important characteristic: if we add to a golden rectangle the square built on its larger side, we obtain another golden rectangle; but if we remove the square drawn on the smaller side, we still obtain a golden rectangle. We can continue endlessly building ever larger or ever smaller rectangles, thus obtaining a progression that has the shape of a continuous spiral, an image of the cosmic vortex whose mystery has neither beginning nor end, an image of the permanent rotation of the universe (fig. 3).

The Pythagorean theory of universal harmony regulated by mathematical ratios that occur in nature and in music was recorded by Plato in

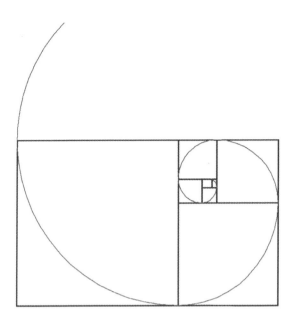

Fig. 3 - *The infinite progression of the golden ratio*

the *Timaeus*, a text widely studied and glossed in the medieval schools. As Rudolf Wittkower wrote in his famous work on *Architectural Principles in the Age of Humanism*, the discovery of these ratios, which are recurrent both in nature and in music, caused people to "*believe that they had seized upon the mysterious harmony which pervades the universe. And on this was built much of the number symbolism and mysticism, which had an immeasurable impact on human thought during the next two thousand years*"[46].

"*Thou hast ordered all things **in measure, and number, and weight**"* (Wisdom 11:21). This phrase in the Book of Wisdom, written in an Alexandrian and Neo-Platonic environment possibly around the middle of the 1st century A.D., also enjoyed immense popularity with the Church Fathers. Numbers and geometry seemed to be capable of draw-

[46] Rudolf Wittkower "Architectural Principles in the Age of Humanism" New York, W. W. Norton & Company, 1971, p. 104.

ing aside the veil of God's arcane dynamic because the whole of visible reality appeared to be subject to them. In the *Somnium Scipionis*, the *Dream of Scipio*, Cicero wrote that the cosmos is the temple of God. Augustine revived Plato's Pythagorean numerology and grafted it onto the tree of the Judaeo-Christian tradition, relying on the authority of this verse from the Book of Wisdom. In so doing, he, like the Platonists, recognised that there is in the universe a rule that can be known through numbers, a rule in which the divinity manifests the mysterious rhythms of its own life. Following Plato and his later commentators, the most important temples were built in the image, and thus in the measure, of the cosmos, in other words in accordance with the numerical ratios that appeared to make up its intimate structural harmony. Thus it is hardly surprising that Christian architecture, too, should have attempted to reproduce the structure of the cosmos both through the rhythm of the numbers that Wisdom had impressed on it and through the orientation and symbols of its buildings. Wittkower studied the geometry and the numerology used in the construction of Renaissance churches, but his words apply just as well to medieval churches, especially to those built after the 12th century, when neo-Platonism and gnosticism resurfaced with such vigour in the Western world: *"Renaissance artists firmly adhered to the Pythagorean concept 'All is Number' and, guided by Plato and the neo-Platonists and supported by a long chain of theologians from Augustine onwards, they were convinced of the mathematical and harmonic structure of the universe and all creation. If the laws of harmonic numbers pervade everything from the celestial spheres to the most humble life on earth, then our very souls must conform to this harmony. It is, according to Alberti, an inborn sense that makes us aware of harmony; he maintains, in other words, that the perception of harmony through the senses is possible by virtue of the affinity of our souls. This implies that if a church has been built in accordance with essential mathematical harmonies, we react instinctively, an inner sense tells us, even without rational analysis, when the building we are in partakes of the vital force which lies behind all matter and binds the universe together. Without such sympathy between the microcosm of man and the macrocosm of God, prayer cannot be effective. A writer like Pacioli goes so far as to say that divine functions are of little value if the church has not been built 'with correct proportions'* (con debita proportione). *It follows that perfect*

proportions must be applied to churches, whether or not the exact relationships are manifest to the 'outward' eye"[47].

For a long time, architectural historians denied the existence of designs for medieval churches, despite the complexity of the Gothic cathedrals which it would be hard to attribute to the empirical execution of mere artisans[48]. Documentary sources, while admittedly scarce and all dating back to the 13th and 14th centuries, tell us nevertheless that architectural elements were designed and planned from the start of the 13th century: architects and master masons used drawings on parchment and wooden models to illustrate their design to their patrons, and they drew patterns directly on the plaster on the building site as instructions for the workers building the church. The first example of such a pattern is to be found in a drawing dated 1201 discovered on the wall of the church of Santa Maria Assunta in Ponte, in the Valnerina, depicting the design for the church's rose window. Villard de Honnecourt's famous portfolio or sketchbook, dating back to the first decades of the 13th century, bears witness to the designing skills of the men who built the great cathedrals and abbeys[49]. In 1265 the contract for the pulpit in Siena cathedral proves beyond all doubt the existence of a detailed drawing by Nicola Pisano, all the details of which are scrupulously described and their full dimensions are given. In 1277 in Perugia there is a record of parchment being purchased for Arnolfo di Cambio to draw his design for the fountain in the city's Piazza Grande. A great deal has been written both about the architectural and urbanistic proportions of Arnolfo's designs, and about his use of geometric patterns *ad quadratum*, which demanded rigorous preparatory drawings[50]. In 1322 Lorenzo Maitani voiced a significant opinion on a plan which had been submitted to him for the enlargement of Siena cathedral: *"It seems to us that this work should be taken no further; because if the work is completed, the church will no longer have the measure in length, width or height that the laws governing holy places demand... Thus we feel that the work*

[47] Ibidem, p. 38.

[48] Cf. Valerio Ascani's exhaustive historiographical synthesis "Il Trecento disegnato. Le basi progettuali dell'architettura gotica in Italia" Rome, Viella, 1997, p. 51 ff.

[49] "Carnet de Villard de Honnecourt" with introduction and commentaries by Alain Erlande-Brandeburg, Regine Pernoud, Jean Gimpel and Roland Bechmann; Paris, Stock, 1986.

[50] For architecture cf. Angiola Maria Romanini "Arnolfo di Cambio" Milan, Ceschina 1969 and for new cities cf. Enrico Guidoni "Arte e Urbanistica in Toscana" Rome, Bulzoni, 1970.

should not continue, for the old church is so well proportioned and its parts are in such perfect ratio to one another in width, length and height, that if anything were to be added to any part, it would be necessary to destroy the whole church if we wished to restore it rationally to the proper measure for a holy place"[51]. Maitani's answer shows that by the 14th century there was full awareness of the existence of a harmonic and proportional rule based on a consolidated tradition, and that it was a rule that must needs be complied with when building holy places. The following century was to embrace that tradition and to codify it in more advanced philosophical terms: "*There were two basic design methods, identified more on the* a posteriori *examination of drawings than thanks to any specific documentary evidence: one was "harmonic", based on mathematical ratios shared with music—indeed they may even have been derived from music—and identified by Wittkower; while the other was geometrical, based on the square, the triangle and the manipulation of those two shapes*"[52].

The ancients had also devised an effective geometric method for laying out the plan of a building on the ground. They used a rope with knots tied at regular intervals along its length. The knots represented lengths or spaces of equal size; by paying out the rope in the proper manner, one could construct a Pythagorean right-angled triangle whose sides measured three and four spaces respectively while the hypotenuse measured five. It was simple to construct other geometrical figures too, just by arranging the rope in different ways. For instance, one could map out an isosceles triangle with sides of four spaces and a hypotenuse of five. This method, which was already in use under the Egyptians and well known throughout antiquity, is also depicted in medieval miniatures[53] and it pro-

[51] "Item videtur nobis, quod in dicto opere non procedatur ulterius; quia postquam opus foret completum, non haberet mensuram ecclesie in longitudine, amplitudine et in altitudine, ut iura ecclesie postulant… Item nobis videtur, quod in opere non procedatur deinceps, cum vetus ecclesia sit adeo bene proportionata et ita bene simul conferant partes sue in amplitudine, longitudine, et in altitudine; quod si in aliqua parte aliquid iungeretur, opporteret invite ut dicta ecclesia destruatur in totum, volendo eam reducere rationabiliter ad rectam mensuram ecclesie" cit. in Valerio Ascani, *op. cit.*, p. 37.

[52] Valerio Ascani, *op. cit.*, p. 35.

[53] A 12th c. miniature in the Bibliothèque Nationale de France, in Paris, shows Saints Peter, Paul and Stephen appearing in a dream to Abbot Gunzo and paying out rope to show him the ground plan of the future basilica at Cluny; while Plato had already said in his *Philebo* that beauty is achieved with the compass, the set square and the rope.

vided an excellent approximation for the construction of complex geo-metrical figures based on triangles. Even façades could be traced out pre-emptively on the ground to serve as a guide for the stonemasons, who would then assemble the parts on them horizontally before cementing them in their proper place in the vertical.

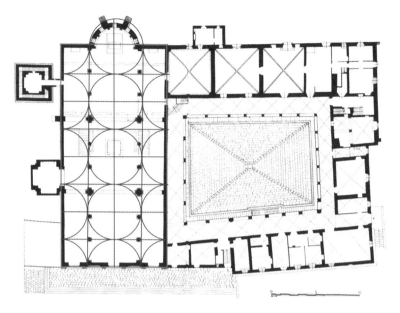

Fig. 4 - *Modular proportioning of the plan of the basilica*

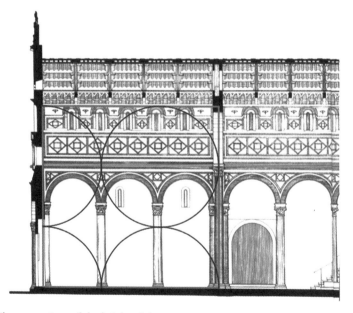

Fig. 5 - *The proportions of the height of the nave*

7. Sacred Geometry in the Basilica of San Miniato

The plan of the basilica of San Miniato fails to fit satisfactorily into a regular modular grid. This may be due to the fact that the building was erected in several stages in order to allow the pre-existing church to continue in use until the new one was ready. The initial design must have been based on strict geometric proportions, yet when the basilica was built, those proportions were only roughly adhered to. We can see how the width of the nave is double that of the side aisles, reflecting a ratio of 1:2, which is the simplest of harmonic chords, the chord of the perfect octave or diapason. The bays in the nave, on the other hand, have a length-to-width ratio of 3:2, which is the harmonic chord of the perfect fourth or diatessaron. And the ratio of the length of each bay to the overall length of the three aisles (central nave and two side aisles) is, to all intents and purposes, 3:4, which is the harmonic chord of perfect fifth or diapente. The fact that the design is basically proportioned leaps out at one from the plan (fig. 4), but even then it is not perfectly accurate. The height of each bay in the nave from the ground to the top of the windows is equal to its length (fig. 5).

We are in for a surprise, on the other hand, if we measure the height of the arcades in the nave, in other words the mystic pathway leading towards the apse. The height of the central arch is in a perfect golden ratio to the width of the nave itself. The arch is thus enclosed within a golden rectangle (fig. 6) and marks out the nave as a cosmic pathway.

We instinctively feel the façade of the basilica to be a harmonic symphony inducing a sense of serene empathy with the place itself and with the sky (fig. 7). This effect is due to its rich and complex marble decoration, where shining white Carrara marble alternates with the dark green of serpentine marble. Five portals, framed by half-columns and surmounted by semi-circular blind arcading, provide the entrances to the

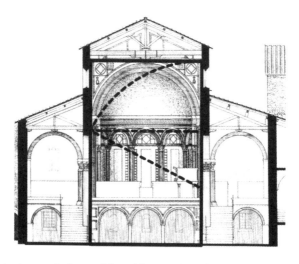

Fig. 6 - *Proportioning on the basis of the golden number of the nave arch*

nave and side aisles, referring symbolically to the number of the sun but also, as we hear in the hymn for the cathedral of Edessa, "*in the likeness of the five virgins in the parable*". The arches are adorned on the inside with horizontal and vertical strips of serpentine: one of the two horizontal strips is positioned at the height of the capitals on the half-columns and coincides with the diameter of the arch, while the other is positioned along a seemingly casual chord close to the top of the arch. The lower register of the façade is completed a little way above these arches by a series of cornices set in a position that bears absolutely no relation to the architectural structure of the basilica, occurring as it does well below the eaves of the aisle roofs. Yet the base of the façade's upper register, in other words the upper part of the façade corresponding to the nave on the inside and capped by a tympanum, is correctly set on this eave line. Like the lower register, so the upper register too is marked by horizontal cornices set in an anomalous position in relation to the overall structure. It also has four vertical grooved pilasters, with an architrave shaped rather like a downward-facing "C" set between the pilasters and the upper cornice (fig. 8). The pilasters divide the upper register of the façade into three rectangular sections. The figure of Christ sits enthroned in majesty in the upper part of the central section, flanked in the section on either

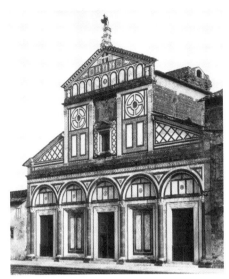

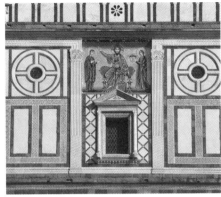

▲ Fig. 8 - *The C-shaped cornices of the façade*

◄ Fig. 7 - *The façade of the basilica of San Miniato in a photograph by Alinari*

side by a wheel with four spokes in the form of a cross set around a central oculus. Below Christ, a rectangular window framed by small columns and capped by an elegant classical pediment, akin to that adopted in the windows of the Baptistry of San Giovanni and of the Collegiata church in Empoli, constitutes the composition's geometrical heart. Just below the impost of the tympanum, in other words at the level of the nave roof eaves, two male caryatids set one at each end of the upper register support two small cornices, which almost immediately finish. The triangular tympanum rises above the basilica's roof to a height that one may be forgiven for (wrongly) believing to be dictated purely by chance, and it is capped by a pinnacle on which the eagle emblem of the Arte di Calimala, or Florence cloth merchants' guild, was placed at a later date. The decoration is obviously far more complex, but the elements described so far determine, with their only seemingly casual positioning, the mystic geometry which pervades the façade and which its designer intended should cause it to vibrate in unison with the music of the celestial spheres.

Most art critics believe the decoration to have been executed at two different times, the lower register at some time in the 11th century and the upper register, possibly with the exception of the pilasters, in the 12th

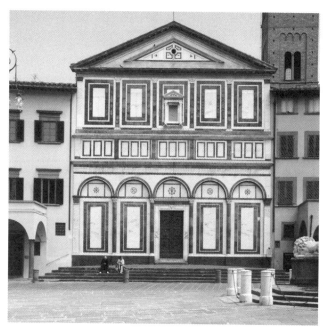

Fig. 9 - *The Collegiata in Empoli*

or 13th century. Yet there are voices singing out of chorus that consider it to be the result of a single project or to have proceeded hand in hand with the building work.

First of all, there is an obvious kinship with the façade of the Collegiata church in Empoli, which an inscription tells us was completed in 1093 (fig. 9). Even though the Empoli façade underwent major remodelling in the 18th century, it appears to have followed the model of San Miniato very closely, most noticeably so in having a lower register framed by five semi-circular arches, while such elements as the window with its classical tympanum and base supported by two lions' heads, the marble-inlay of a vessel, or vase, enclosed within an octagonal star (figs. 10 and 11) above the main door and the Lucifer's eye in the centre of a four-spoke wheel are straight copies. It has been suggested that only the lower part of the façade of San Miniato can be dated to the 11th century, yet its unquestionable affinity of vocabulary with the Collegiata can also be seen in certain elements in the central and upper parts. Some

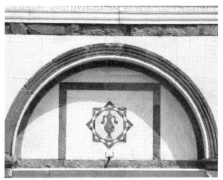 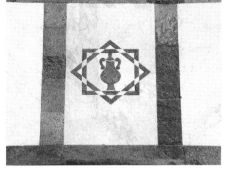

Fig. 10 - *The Vessel on the façade of the Collegiata*

Fig. 11 - *The Vessel on the façade of San Miniato*

scholars have circumvented the problem by arguing that Sant'Andrea may be a prototype which was then refined and perfected in San Miniato, yet despite the unsympathetic 18th century alterations which allow us to perceive the original design only in part, it seems quite clear that the façade in Empoli is in fact derived from the more eminent original in Florence.

The issue might be resolved by a hypothesis put forward by Sanpaolesi who, in an analysis of the lexicon and the names it contains, considers the date in the Collegiata inscription to refer to the church's foundation rather than to the construction of the façade and argues that it was affixed some time after 1093, possibly towards the middle of the 12th century[54]. Thus according to Sanpaolesi, the façade of San Miniato would already have been finished by that date.

But however long it took to build, there can be no doubt that the scansion of the geometric grid in San Miniato bears no relation to that of the church's structural body; rather, it reflects a self-contained rationale implying an independent, erudite, careful design of the decorative appa-

[54] For a summary of the various hypotheses cf. AA.VV. *La Basilica di San Miniato al Monte* Florence 1988, p. 51 ff.; the text of the inscription in the Collegiata church in Empoli is as follows: "Hoc opus eximii praepollens arte magistri bis novies lustris annis tam mille peractis ac tribus est ceptum post natum virgine verbum quod studio fratrum summoq. labore patratum constat Rodulfi Bonizonis presbiterorum Anselmi Rolandi presbiteriq. Gerardi unde deo cari creduntur et aetere clasi", reproduced in *La Chiesa Fiorentina. Storia, arte, vita pastorale*, 1993, p. 291.

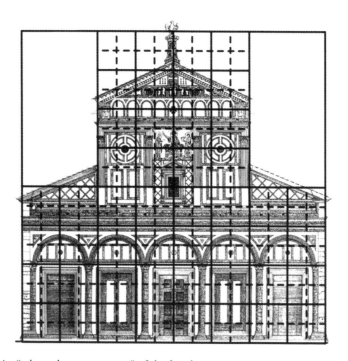

Fig. 12 - *An "ad quadratum scansion" of the façade*

ratus in which even the apparent anomalies mentioned earlier find their un-expected place. Even if the base had been built at an earlier date, the upper part of the façade of the church would still have been designed in such a way as to present a consistent and interlocking whole with the earlier part.

First of all, it is easy to see that the façade was constructed on a geo-metric grid *ad quadratum*, a method frequently employed by medieval builders (fig. 12). It is inscribed within a square whose sides can be di-vided into an 8-module scansion, each one of which is 5 old Florentine ells long[55]: the width of the side aisles corresponds to 2 modules each, while the nave is 4 modules wide; thus the relationship between the nave and the side aisles is governed by the musical ratio of the Pythagorean diapason (the octave), or 1:2.

[55] An ell is about 60 cm.

The upper part of the square of the façade does not coincide with the summit of the tympanum but with that of the pinnacle on which the Arte di Calimala placed its emblem, an eagle on a bolt of cloth, in 1401. The pinnacle (without the eagle, which does not fit into the geometric grid) thus appears to be a crucial element in the symbolic coherence of the whole façade.

It is worth noting that the size of the square expressed in old Florentine ells is 40 ells, which is a mystic number linked to spiritual transformation and regeneration: 40 were the years the Israelites spent wandering in Sinai before reaching the Promised Land, 40 the days Christ spent in the wilderness, 40 the days of silence before Easter. The number 40 seems to be connected with the concept of the Door of Heaven, the gateway providing entry to a higher world. The 5-ell module is commensurate with the number of the spirit; repeated 8 times, it appears to represent the spiritual ascent through the seven spheres of the planets up to the eighth heaven of fixed stars, the Ogdoad of the Blessed. Thus the numbers used in the façade indicate the church's function as a gateway or Door to Heaven, a Jacob's ladder.

Within the 8-module grid, the building is inscribed in two equal rectangles, both of which have a shorter side 4 modules long and a longer side 8 modules long, corresponding to the façade of the nave and to the entire base up to the roof of the side aisles respectively. Thus we encounter the 1:2 ratio of the diapason twice.

When geometric grids of this kind are identified in ancient buildings, there is always the suspicion that an attempt is being made to force the building to fit some preconceived hypothesis. In the case of the façade of San Miniato, however, even the apparent anomalies in the decorative apparatus find a cogent explanation in the light of the grid's geometry; the horizontal alignments of the square modules are perfectly mirrored in the serpentine marble strips set at the base of the blind arcades surrounding the doors, in the cornice that concludes the lower register in an uncustomary position, in the line produced by the varied rhythm of the grooves on the pilasters, in the horizontal arms of the crosses set inside the cosmic wheels, and in the short cornices supported by the two caryatids that define the imposts of the tympanum. In every single case these are decorative elements which have absolutely no connection with the structure lying behind the façade, and which suggest that the decorative scheme was designed and built at a later date than that structure.

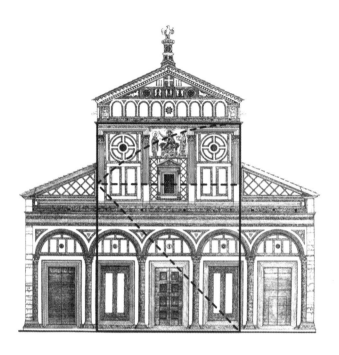

Fig. 13 - *The rectangle constructed by the projection of the diagonal of the square*

The square grid, however, is not the only element in the façade's complex geometric design. In particular, it fails to resolve the enigma of the square cornices set between the capitals of the pilasters and the upper cornices. Yet their positioning, too, reflects a precise design, producing two rectangles of lofty symbolic and mystical significance in the façade of the nave. If, starting with the 4-module square forming the lower façade which ends with the horizontal alignment determined by the different division of the pilasters, we draw a diagonal line along the extension of one of its vertical sides, we obtain a rectangle whose short side coincides with the upper part of the cornice (fig. 13). The ratio between the side of the square and its diagonal, described in classical times by Vitruvius, is immeasurable but can be expressed approximately as $\sqrt{2}:1$; for that very reason it was imbued with immense mystical significance from ancient times to the Renaissance, symbolising divine transcendence. The

Fig. 14 - *Pythagoras' triangle with sides of 3 and 4 modules and a hypotenuse of 5*

alignment of the pilaster capitals, on which the base of the square cornices rests, forms in its turn the side of a second sacred triangle comprising two right-angled triangles joined by the hypotcnuse, whose sides are in a ratio of 3 and 4 (diatessaron) and whose hypotenuse is 5 (fig. 14). We have seen Plutarch's explanation for this special Pythagorean triangle: it was held to enclose the mystery of the power of the Son as the sum of the powers of the Father and of the Holy Spirit. The latter was understood in the fcmale sense, as the Hebrew word *ru'ah*, which is feminine, would appear to indicate. The mid-point of the rectangle's greater axis coincides with the face of Christ, which is also the center of a circle inscribed in the square encompassing the entire upper register.

The golden rectangle is built according to an immeasurable ratio similar to the ratio that exists between the side and the diagonal of a square, and as we have seen, it is one of the most ancient and widespread

Fig. 15 - *The golden rectangle framing the central doorway*

geometric symbols for indicating the transcendence and spiritual origin of the cosmos. In the sophisticated symbolic programme of the façade, therefore, it comes as no surprise to find the golden number linking the profane external space to the sacred space inside the basilica. The central portal is enclosed in a golden rectangle whose short side includes the thickness of the half-columns and whose long side ends at the top of the lunette (fig. 15). Thus the portal represents the introduction to the mystery of spiritual rebirth and the beginning of the path leading to the spiritualisation of the body.

But there is more: there is the last and most complex step in our geometric journey through the compendium of wisdom that this façade represents. There was a traditional and enigmatic maxim among the medieval master masons: *"Three tables support the Grail: one is square, one is round and one is a rectangle. All three have the same surface area and*

their number is 21". This maxim concealed one of the most jealously guarded secrets of the confraternities, which was revealed only in the course of an initiation ceremony at the end of a patient spiritual journey. Louise Charpentier, in a controversial yet in many ways enlightening text[56], surmised that the number 21 might in fact stand for the ratio 2:1 in the first rectangular table. As we have seen, this table is very much in evidence on the façade, the rectangles of the base and of the vertical part corresponding to the nave both reflecting it. A rectangle with a ratio of 1:2 not only constitutes the first of the musical ratios (the octave), but it also possesses another significant peculiarity: its diagonal is equal to the square root of 5. Thus it contains all three terms that form the mathematical formula of the golden number:

$$\frac{\sqrt{5} + 1}{2}$$

Discussing Chartres cathedral, Charpentier observers that the golden number, which is 1.618, can be linked through a few mathematical operations to 3.1416, the irrational number known as *Pi*; in other words, it potentially contains the principle of the squaring of the circle. Squaring was a geometrical and mathematical problem of immense symbolic significance because, in sacred geometry, the square stands for the earth while the circle is the image of the sky, or heaven. This led the ancients to believe that the formula for squaring the circle would give them the key to joining heaven to earth, the macrocosm to the microcosm, like some kind of enormously powerful talisman.

In 1882 the German mathematician Ferdinand von Lindemann demonstrated that it is impossible to square the circle using only a set square and compass. Yet it can be achieved with an acceptable degree of approximation if one starts precisely with a rectangle with a ratio of 1:2.

A square whose diagonal is equal to the greater side of a 1:2 rectangle will have the same surface area as that rectangle. This is the type of square that frames the façade; if we build it on the horizontal axis of the 1:2 rectangle in the lower register, the apex of the isosceles triangle forming half of it will coincide with the eight-radius star set in the centre of the upper register. But if we build it on the vertical axis of the nave

[56] Louise Charpentier, Turin, Arcana Editrice, 1972, p. 119 ff.

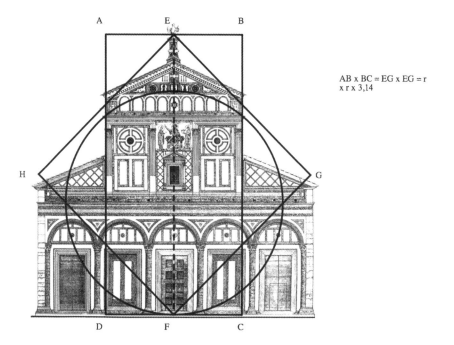

AB x BC = EG x EG = r
x r x 3,14

Fig. 16 - *The three tables supporting the Grail*

rectangle, its centre will coincide with the centre of that axis in the exact centre of the window. It is possible to draw a circle having the same surface area as this square, thus achieving the circle's squaring; in other words, magically conjoining heaven and earth (fig. 16).

We need to start by building a figure known as a seven-point star, a mystical image that symbolises the sacred septenary, in other words the sum of the creating Trinity with the quartenary of the generated world; this, because the Creation took place over seven days and, in the traditional world, seven are the planetary spheres that preside over life on earth. The star is formed from the diagonals of a heptagon.

The construction of a regular heptagon was another problem that could not be resolved using a set square and compass, which was why it so fascinated the ancients. There are various techniques that provide perfectly acceptable approximations, one of which Galileo suggests in his

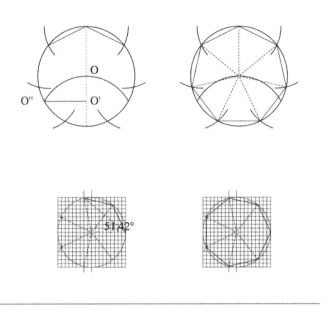

Fig. 17 - *Construction of the heptagon*

Treatise on Fortifications. Starting with a circle, first you find its vertical diameter. Using its lowest extreme as your centre, you then draw a circumference whose radius is equal to the original one. Then you join the points on which the two circumferences intersect with one another, and you take the distance between one of the intersections and the vertical diameter as the side of your heptagon.

Yet one can achieve a more accurate result if one starts with a grid of square modules. By drawing a circle with a radius of nine modules inside the grid, one can find the perpendicular to the vertical diameter of the circle lying two modules away from it. The points where this perpendicular meets the circumference form two of the heptagon's apexes. The others can be obtained by identifying the bisecting line of the angle formed by the junction of one of the apexes identified with the centre of the circumference, and by the circumference's horizontal diameter. In this

case, the margin of error in the construction of the heptagon is lower than one-thousandth (fig. 17).

Finally, one can also build a heptagon with the rope used by medieval master masons, making twelve knots to divide it into thirteen equal lengths or spaces. This gives an isosceles triangle whose sides consist of four spaces each, while the base consists of five. If we make the base coincide with the vertical axis of the façade and then mirror the equal triangle around the axis, we can determine the angles enclosed within the star's radii one by one. Each one will measure 51°19'. Given that an accurate subdivision of the circumference into seven parts produces the figure of 51°25'71", the master masons probably made a slight manual adjustment to ensure that the ropes of the circumference subtended by the angles were all equal.

The ancients had worked out that the angles of 51°25' enclosed within the star's radii were linked to *Pi* and that they thus held within them the path to resolving the squaring of the circle. Sure enough, we find a very similar angle in the inclination of the Great Pyramid (51°52'), where it determines "*the unique geometric property that the pyramid's perimeter is in the same ratio or proportion to its height as is the circumference of a circle to its radius. This ratio is 1/2 Pi, where Pi is the transcendent number 3.1441...*"[57]. Thus the seven-point star, or at least the sacred geometric method that made it possible to bring a square down to a circle, in other words to bring heaven down to earth, was already known to the ancient Egyptians.

The seven-point star, if correctly positioned on the axis of the initial rectangle, appears to be the key to determining the circle with a surface area equal to it and to the square that has this axis for its diagonal. It took me quite a few attempts to identify the star's insertion point, but in the end I discovered that it is necessary to divide the axis into 90 equal parts, a mystical number which, being a product of nine, of two and of five, is connected to the Pythagorean triangle to which Plutarch refers so frequently. We have also seen that one of the methods for the construction of the pentagon is also based on the number nine. If we place the centre of the star on the twenty-first of the axis's 90 parts, we will see that the surface of the circle coincides with that of the other two generatrix fig-

[57] Kurt Mendelssohn "The Riddle of the Pyramids", 1974, Praeger, New York, p. 59.

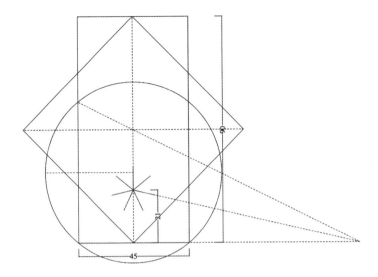

Fig. 18 - *Squaring the circle*

ures, the 1:2 rectangle and the square constructed on its greater axis. Thus the traditional enigma already contains the solution: in all of the combinations that we have discussed, the number 21 is the key to achieving the squaring of the circle (fig. 18).

Applying this procedure to the façade of San Miniato, we see that the centre of the star corresponds to the midpoint of the architrave over the central door, while the radius that determines its circumference meets the upper register side at the same point in which the alignment of the cosmic wheels' horizontal arms converge. And lastly, the diameter of the circle coincides with the horizontal band of serpentine marble placed in an anomalous fashion inside the lunettes of the lower register which, as we have already seen, corresponds also to the greater axis of one of the golden rectangles (fig. 19).

"*Three tables support the Grail*"; thus it comes as no surprise to find the Vessel of Spiritual Transmutation, the Grail, above the three tables of the façade of San Miniato, centred over the main door. This Vessel contains the *Logos*, the *Chokhmah*, or wisdom that creates, sought by the Qabbalists and the mystics, the origin of the cosmos and the sublime key of the Door

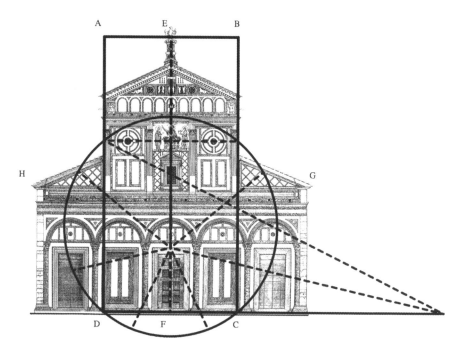

Fig. 19 - *The circle squared, on the façade of San Miniato*

to Heaven. The Name above all names, before which all knees bend in heaven, on earth and in the netherworld, vibrates within this eternal *Logos*.

It is worth pointing out that the Grail cycle appeared suddenly and spread rapidly in the very years in which the façade of San Miniato was being built. Chretien de Troyes wrote the *"Perceval ou le Conte du Graal"* towards the end of the 12th century; and in 1190 Robert de Boron wrote his *"Joseph d'Arimathie"*, in which the Grail is described for the first time as the cup that received the blood of Christ. The *"Queste del Saint Graal"*, generally believed to have been compiled by Cistercian monks, appeared in 1210 or thereabouts, and almost contemporary with it (around 1207) was the publication of Wolfram von Eschenbach's *"Parzifal"*, probably of Templar origin. Finally, the *"Perlesvaus"*, which states that the Grail, while undergoing five changes of shape, is in fact the sacred Vessel, was published anonymously in 1225.

Thus we should not be surprised to find the Vessel of the Grail in the center of the complex mystic geometry on the façade of San Miniato. It is set in the centre of an octagon formed by the rotation of two squares on their diagonals. The symbolism of the octagon is linked to the concept of rebirth and of the passage from earth to heaven, thus highlighting the significance of the Ark within which the *Logos* resides[58].

In conclusion, all of the elements on the façade have their logical place in the symphony of geometric ratios that we have identified, creating that harmonious composition of the parts that so instinctively strikes and reassures the observer. It also becomes clear why the façade had to be taller than the church behind it, and why the triangular tympanum rises so far above the roof. And lastly, it is quite clear that this composition cannot be the result of separate building campaigns but has to be the fruit of a single, consistent project designed after the church itself was built.

[58] See Renzo Manetti "Desiderium Sapientiae. Simboli esoterici nella città antica" Florence, Giuntina, 1996.

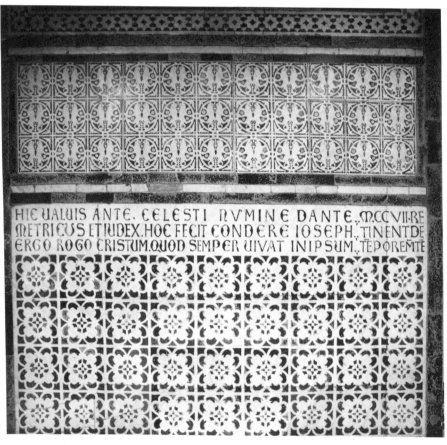

Fig. 20 - *The inscription on the floor*

8. THE MARBLE FLOOR

A sophisticated pathway inlaid with marble leads from the main door to the altar of the crucifix, where St John Gualbert had the vision which prompted him to convert. Its motifs are varied and are reminiscent of the decoration on oriental fabric. Yet they contain a symbolic message, and measurements and numbers are once again a crucial factor in helping us to understand that message. Just as we have seen with the façade, so this marble pathway too conceals the mystery of the conjunction between material and spiritual nature.

The pathway consists of seven slabs of different shapes and sizes.

Before the entrance we find a rectangle divided into three panels of different sizes. 81 small panels each contain 4 tulips which curve towards the centre, forming a figure with 8 lobes. These small panels are disposed in 9 rows of 9 panels each, thus forming a continuous square surmounted by the dedicatory inscription (fig. 20). Above this, the design continues with a rectangle of 33 panels (11 across by 3 up), in each of which two lions face each other, with 4 flowers and 5 petals between their paws. The squinch of each panel contains 4 doves with their wings spread out.

The rectangle is followed by five square slabs of the same size as the square formed by the 81 small panels. The first slab has two borders decorated with 8-point star motifs. A continuous band unfurls inside them, forming a circle in the centre and four smaller circles in each direction. Inside the circle 2 lions face each other, surrounded by 16 smaller circles with floral motifs which also form stars with 8 petals or radii. The 4 lateral circles also contain figures of lions facing one another. In the corners we find another 4 circles, inside which a series of complex decorative motifs all hark back to the 8-point star shape. Between the circles, paired birds face each other, separated by the stem of a flower (fig. 21).

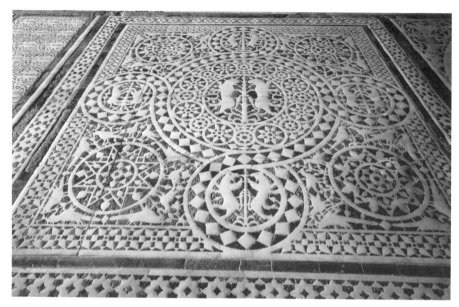

Fig. 21 - *The first square slab of the floor*

This is followed by a square containing the wheel of the zodiac; in the squinches, 4 griffins grasp serpents in their claws, held up by two figures that are human from the waist up and serpents from the waist down.

In the third square, 33 small circular panels contain 2 doves facing each other, separated by the stem of a flower, surrounding a central square containing an eagle. The eagle holds a serpent in its mouth, and on either side of its body it enfolds two circles with 8 radii under its wings.

The fourth slab is also square and it has a smaller square in its centre containing 2 lions facing one another. Another 33 minor panels surrounding the central panel each contain 2 griffins facing each other (fig. 22).

The fifth square slab comprises 36 small square panels, each containing 2 lions facing each other.

The pathway ends with a rectangular slab consisting of 24 small square panels decorated with complex floral and stellar figures, all of which hark back to the number 8. The rectangle is grafted onto a band of 38 small square panels which totally surrounds the altar of the crucifix.

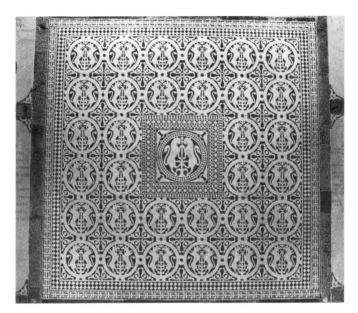

Fig. 22 - *The fourth square slab of the floor*

Thus the whole pathway is divided into seven passages or stages. One is struck by the analogy with the stages in ancient Mithraea marking the initiatory pathway leading towards the figure of Mithras, and symbolically reproducing the heavenly ladder travelled by souls through the seven planetary spheres.

At first sight it is difficult to work out why the five square slabs should be accompanied by two rectangular ones. By altering their width, the pathway could easily have comprised only square panels. But in point of fact, the two rectangles are necessary in intimate sacred geometry to mark the start and the completion of the journey (fig. 23). The greater side of the rectangular slab before the entrance—containing the inscription—is equal to the diagonal of the squares following it. This is the immeasurable ratio and, as such, a symbol of the divine rule impressed on the cosmos; we have seen this also in the geometry of the façade. It tells us that the space inside the door belongs to a dimension which is not that of matter, and thus it cannot be measured with integers.

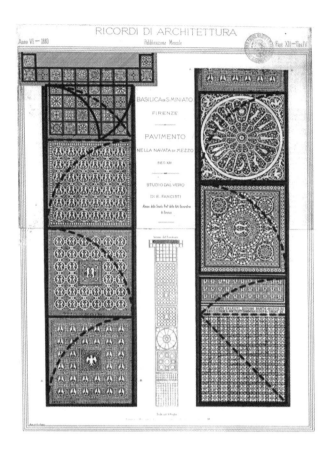

Fig. 23 - *The sacred geometry of the marble guide*

The final rectangle set at the end of the pathway, on the other hand, is a golden rectangle which, if added to the square preceding it, forms another golden rectangle. It symbolises the fact that the pathway ends outside of time, in eternity.

The number 9 recurs again and again in the marble pathway. Dante associated this number with Beatrice as an allegory of the Wisdom that teaches us the path leading to heaven: "*According to the infallible truth, this number was her own self: that is to say by similitude, as thus. Thus, three being of itself the efficient of nine, and the Great Efficient of*

Miracles being of Himself Three Persons (to wit: the Father, the Son, and the Holy Spirit), which, being Three, are also One, this lady was accompanied by the number nine to reveal that she was a nine, that is, a miracle whose sole root is the sublime Trinity"[59].

In the first rectangle, the lions facing each other symbolise the need to mend the rift between man's two natures, the material and the spiritual.

The arcane dedicatory inscription, which has been interpreted in various different ways, is set between the panels with lions and those with flowers:

> *"hic valvis ante. celesti numine dante;.mccvii.re*
> *metricus et iudex. hoc fecit condere joseph;.tinent de*
> *ergo rogo cristum. quod semper vivat in ipsum;.tepore mte".*

It is made up of two parts. The words after the semi-colon in each line must be read separately, inasmuch as they form a phrase which is distinct from that formed by the words that precede them: *retinent de tempore et morte*, or: *these things preserve from time and death*. The first part, on the other hand, consists of unsophisticated hexameter verse which, at first sight, can be roughly translated as: *here before the doors, by the grace of God, Joseph, poet and judge, caused these works to be executed, therefore I pray to Christ that he may always live in Him.*

Scholars have generally taken this Joseph to be a generous magistrate who donated the mosaic floor for the good of his immortal soul. They argue that the good judge was also something of a dab hand at poetry, to the point where he called himself a *metricus*, which they somewhat arbitrarily translate as *versifier*, or poet. In actual fact, there is no contemporary record of any judge by that name. Even the name itself, Joseph, is a rarity in medieval Florence. It does not occur in a single known document of the period, with one exception that goes back precisely to the time of the inscription: 29 April 1218, a mere 11 years after the date carved on the slab. There is one document mentioning an abbot named Giuseppe[60], and he happens to be the abbot of the monastery of

[59] Dante Alighieri "Vita Nuova" XXIX, 4; tr. Dante Gabriel Rossetti.
[60] ASF Olivet. cit. in Davidsohn, 1956-1968, I, p. 1040.

San Miniato. Considering the name's rarity, it is unlikely to be a coincidence. We are probably far closer to the mark if we identify the Joseph in the inscription dated 1207 with the abbot of 1218 rather than with some unknown judge. But that means that we also have to rethink the meaning of the words *iudex* and *metricus*. The *metricus* is the man who established the proportions and measurements of the floor, while the *iudex* is the person who oversaw the work, ensuring that it was a faithful execution of the original design.

The other terms used in the phrase are likewise ambiguous and appear to refer to the basilica's cosmic symbolism. *Celesti numine* can be freely translated as *by the grace of God*, but in a more literal sense it appears to refer to the sacred law of heaven which is revealed in the numbers and proportions of harmony. If this is the case, then *celesti numine dante* means *impressing on this work the law of heaven*, the very same law whose arcane configuration is represented by the wheel of the zodiac.

Valvae means the wings or leaves of a door, but the term also refers to the valves of a shell, an image of creation which Piero della Francesca, for instance, depicted behind the cosmic egg in his "Madonna dell'Uovo" altarpiece in the Brera Gallery in Milan. Shells are also the precious receptacles in which pearls, an ancient symbol of spiritual perfection, are formed. Thus the valves in the inscription appear to allude to the basilica as the egg of wisdom in which one is born again to the eternal dimension of the spirit.

If this is so, then the symbolism in the first of the five square slabs appears clearer. The two lions in the centre portray the two natures, matter and spirit, that must unite to re-establish the primordial unity which existed before Adam's fall. The griffins surrounding the lions also symbolise this conjunction of opposites because they join the lion to the eagle, the energy of the earth to that of heaven. This is why the griffin was also a symbol of Christ, in Whose person the perfection of both natures was joined. Dante's griffin pulls the chariot in which Beatrice was to ride, an image of the chariot seen by the Prophet Ezekiel on which the Hebrew esoteric tradition was founded.

All the figures in the square are based on the symbolism of the number eight, forming eight-point stars, or flowers with eight petals. Eight is the number of spiritual perfection, the number of the fixed stars that embrace the planets, and for the neo-Platonists it was the seat of souls. The

eighth day is also a symbol of eternity, of the timeless dimension of the spirit, coming after the seven days of creation. Once again, through the number eight, Joseph the wise was reiterating the allegory of the stair-way joining earth to heaven.

We shall return later to the figure of the zodiac which occupies the second square.

In the centre of the third square we find an eagle, the symbol of heavenly energy. But this eagle is holding a serpent tight in its beak. The image can be read as an allusion to the victory of good over evil, but I think it better fits the overall symbolism of the floor to see it as a refer-ence to the union of cosmic and telluric energy, rising lithely from the depths of the earth like the snake which symbolises these energies. Both energies converge in a thin place, causing the architectural rhythms of the basilica to echo with the music of the spheres in harmonious accord with the whispers of mother earth. It is necessary for matter to be dragged up-wards, for the strength of the earth to join the strength of astral space, in order to achieve the miracle of spiritual regeneration. The serpent which Moses raised up on a copper staff saved the Israelites from the vipers' sting; St John the Evangelist uses the serpent to symbolise the Son of Man raised up on the Cross to save mankind. Around the eagle, 32 pairs of doves, the symbol of matter purified, face each other around a branch.

At the centre of the fourth square, we once again find two lions fac-ing each other, surrounded by 32 pairs of griffins. The symbolism of the union of the two natures is also confirmed by the number of the 32 small panels, in which the quadruplicity of the material world is joined with the eight of eternity.

In the last square, 36 pairs of lions face each other inside the same number of circles, a serene echo of the 36 decans of the zodiac into which the heavenly vault is divided in astrology. This tells us that our journey is nearing its end.

Finally, the golden rectangle before the altar of the miracle contains only geometric and paradisiacal images of stars and flowers, where the number eight is constantly repeated. This figure marks the end of the journey, the peace of the eighth heaven, the garden of paradise where time and death lose their power: *retinent de tempore et morte*.

As we can see, the complex numerical symbolism of this marble guide is akin to that on the façade of the basilica. This suggests that

Abbot Joseph was the man who devised the symbolic programme for both, and that at least the upper part of the façade, like the floor, dates back to the beginning of the 13th century—a contention borne out also by the unquestionable stylistic affinity between the figures on the tympanum and those on the mosaic floor.

9. THE ZODIAC

The cosmic symbolism of San Miniato is clearly impressed in the magnificent figures of the zodiac (fig. 24). This zodiac appears to be very close in date and style to the zodiac on the floor of the Baptistry of San Giovanni. An image of the sun lies in the centre of both: stylised and geometric in San Miniato, anthropomorphic and radiant in the Baptistry. The signs of the traditional constellations are set within a cosmic circle which is inscribed, in its turn, within a square. The figure of a circle inscribed within a square, repeated in both representations of the zodiac, indicates once again the union of heaven and earth. In sacred geometry, the circle was associated with the cosmos because the heavenly vault, of which the signs of the zodiac are a part, has the appearance of a hemisphere for the earthbound observer. The square, on the other hand, as explained above, was the symbolic representation of the earth and of space–time. Four cardinal points organise space, its matter is composed of four elements, and four phases of the moon mark its time. Thus the figure of a circle inscribed in a square was an effective representation of what for the ancients was self-evident, namely that heaven and earth are so closely interlinked and interdependent that whatever happens in heaven is reflected on earth, and everything on earth has its counterpart in heaven. Man stood at the junction of these two worlds, harbouring both within him, which is why he may be called a *microcosm*.

Inscribing the cosmic circle in a square, however, also appears to indicate a desire to link astronomic symbolism to the symbolism of the celestial Jerusalem mentioned in the Apocalypse, which is square and characterised by the constant repetition of the number twelve. Thus the corner figures subdivide the signs of the zodiac into four sectors of three signs each, corresponding to the sides of the holy city, in each of which there are three doors. The city is illuminated by the light of the

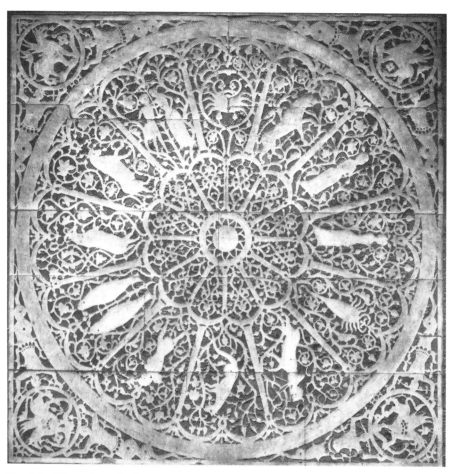

Fig. 24 - *The zodiac wheel in San Miniato*

Logos, of which the sun in the centre of the zodiac is an allegory: the Wisdom that created and ordained the entire universe, the Lord of Time and of the movements that regulate and mark the rhythm of our existence. If we consider the Lord of Time, we can immediately understand why the believer holds his breath when uttering the Name during his recital of the hesychastic prayer, and why certain apocryphal gospels tell us that time stood still for a brief moment when the Virgin gave birth in Bethlehem. In both cases, eternity breaks into time and

resumes possession of it, given that time belongs to eternity as a child belongs to its mother.

In the corner squinches between the circle and the square, both zodiacs show four winged griffins holding a serpent, supported on either side by two half-man half-serpent figures with their arms upheld. We have already discussed the symbolism of the griffin as representing the union of the perfection of heaven and earth. The griffin captures the earth and raises the telluric energy of the serpent up to heaven. The anthropomorphic figures supporting them also participate in the earth's mysterious, serpent-like energy and subject it to the griffin as the chthonic world is subject to the brightness and radiance of the Word. The intertwined griffins and serpents set in the squinches of the two zodiacs are thus consistent with the tripartite structure of the basilica into nave, crypt and raised chancel, which also represents the joining of the three cosmic levels.

The zodiac in the Baptistry appears to be oriented in the traditional manner because the figure of Aries lies to the east, towards the rising sun at the spring equinox, which occurs under the sign of Aries, the sign that marks the symbolic start of the zodiac. In the cult of Mithras, the spring equinox, when the sun enters the sign of Aries, marked the beginning of the year. An inscription in the mithraeum of Santa Prisca in Rome reads: *"Primus et hic Aries ordine currit"* or *"here too, Aries advances first in orderly fashion"*, clearly referring to a mathematically determined movement of the heavens. In the *Divine Comedy*, Dante places the creation of the world under the sign of Aries: *"The time was the beginning of the morning/ and up the sun was mounting with those stars/ that with him were, what time the Love Divine/ at first in motion set those beauteous things"*[61]; later, Marsilio Ficino upheld the same argument in the Renaissance [62].

The fact that the sign of Aries is set close to the sacred building's entrance, which in the case of the Baptistry coincides with the east, strengthens its cosmic symbolism. This anomalous coincidence is due to

[61] Inf. I, 37-40.

[62] *"It is also possible to conjecture that the world has a time of its own birth: to be precise, when the Sun then found itself in the first minute of Aries, because each year, through the same point, fate turns again like a world being reborn"* Marsilio Ficino "De Vita", edited by Albano Biondi and Giuliano Pisani, Pordenone, Biblioteca dell'Immagine, 1991, III, 19; *op. cit.*, p. 351.

the special function of the Baptistry, whose main door (now known as the Gates of Paradise) had to face the cathedral because the Baptistry was ancillary to it.

The zodiac in San Miniato, on the other hand, lies on the floor inside the main door, but unlike the San Giovanni zodiac, the sign facing the entrance is Capricorn, which thus faces north-west like the axis of the basilica itself. This means that Aries, the traditional start of the zodiac, is neither the first sign that anyone entering the church encounters, nor is it the sign facing east. Facing east we have Taurus. All of this is clearly deliberate, intentionally designed to ensure that Capricorn sits at the entrance to the holy place; if Aries had been set facing east, we would have encountered Sagittarius on entering the church, but Sagittarius has no special significance in sacred symbology.

It has been argued that the Taurus facing east is a symbol of Christ sacrificed, referring to an archaic tradition harking back to the Mithraic mysteries[63]. The explanation holds a certain appeal, but we cannot accept it in full, and certainly not where it extends the symbolism of Taurus to Christ. Yet there are some symbols of Mithraic origin in San Miniato, which were possibly handed down through the great vehicle of gnostic neo-Platonism[64].

I strongly believe that the orientation of the zodiac in San Miniato can be linked to the neo-Pythagorean doctrine of the journey of souls as they

[63] Ibidem, p. 52 ff.

[64] In the Mithraic cult, Taurus was associated with the female divinity, the Moon, Mother of the waters of creation: the points of the moon's sickle are indeed reminiscent of a bull's horns. Porphyry asserted that the Moon is Taurus because it achieves its greatest energy when it is in that constellation. Lactantius Placidus also stressed the Moon's identity with Taurus. Mithras sacrifices the bull for his death, in other words the new moon, to spread life on earth in the form of life-giving rain. It is also worth mentioning that the bull was associated with the cult of Cybele and of the goddess Ma, her counterpart in Cappadocia, in other words with the cult of the Great Mother, and that the ritual known as *taurobolium* was performed at the solemn festivities in honour of the goddess that culminated in the so-called Festival of Joy on 25 March, at around the time of the spring equinox. Thus Taurus appears to be ancestrally linked to the female divinity, to the Great Mother, and to the spring equinox, in other words to the direction of the rising sun, just as it is shown in the zodiac in San Miniato. Porphyry, in a work to which we shall be returning later entitled *"De antro nympharum"*, states that Mithras occupies the place of the equinoxes in the zodiac because he is the intermediary god who links men to heaven, and so he has to be in a position midway between the two solstices. The symbolism of Taurus set in the east therefore appears to include, by extension, the symbolism of Mithras, but certainly not that of Christ.

descended and rose again through the planetary heavens until they reached the level of the stars. The belief in the planetary ascent of souls harked back to Plato's *Timaeus*. According to Plato, God used the spiritual matter left over in the cup in which he had shaped the Soul of the World to create human souls, assigning a fixed star to each one. From the level of the stars and constellations of the zodiac, souls are perennially reincarnated, travelling through the planetary spheres, which endow them with a luminous body and the traits of their character. The souls of those who have lived a just and blameless life are able, on death, to retrace their steps up the planetary ladder to their own star, while the others continue to transfer into other bodies until they have been competely purified. This concept was incorporated into Mithraic ritual, where the initiated symbolically ascended the planetary ladder step by step until they reached the eighth heaven. The descent and return of souls through the planetary spheres is also described in Hermetic works, in particular in the *Pymander*.

The neo-Platonist philosopher Porphyry provides an exotic interpretation of a passage from the 13th book of the *Odyssey*, in which Homer tells us that the Phaecians set the sleeping Odysseus down on the beach of Ithaca close to a grotto sacred to the Nymphs. This cave had two doors, a northern one for mortal men and a southern one for the immortals. In his *De antro nympharum,* Porphyry appears to be likening this passage from Homer to a theology akin to that of the Mithraic cult, in which the grotto is a symbol of the cosmos, where the spheres of the fixed stars rotate permanently in the opposite direction to that of the planets. Porphyry adds that as souls travel from the heaven of the stars, they have two zodiacal doors for their heavenly voyage and that these doors correspond to the two solstices, one set in the sign of Capricorn and the other in the sign of Cancer. Souls descend into the sphere of the planets through the door in the sign of Cancer at the summer solstice, and they return through the lowest point on the zodiac, the winter solstice, by the door in the sign of Capricorn. Thus, Porphyry tells us, Homer could state that the northern door is set aside for mortal men and the southern door for the immortals, by which he meant men's immortal souls. According to the image described by Porphyry, the zodiac should be depicted with Capricorn at the beginning of the journey and Cancer at the opposite end, which is exactly the way it is shown on the mosaic carpet on the floor of San Miniato.

Writing in the fourth century, Macrobius in his comment on the *Somnium Scipionis* referred back to the *De Antro*, both describing the descent of souls from the sphere of fixed stars through the heavens of the planets and their subsequent return, and pointing to the two solstices as the Door to Heaven: *"The descent whereby the soul comes down from heaven to the lowliness of this life occurs in the following order. The Galactic Circle, with its long journey through an oblique orbit, revolves around and embraces the Zodiac in such a way that it intersects the two so-called signs of the Tropics, namely Capricorn and Cancer. The Physicists have named them the Doors of the Sun because, when the solstice takes place in one or the other, the sun is prevented from continuing its journey further, and it commences its return journey along the path of the ecliptic (or belt), from whose confines the Sun never departs. Through these doors it is believed that souls travel from heaven to earth and from earth to heaven. For this reason one is called the Door of Men and the other the Door of the Gods; the door of the gods is Capricorn because it is through this door that souls return to the seat of their immortality and to the abode of the gods. This is what Homer means in his divine wisdom when he describes the cave of Ithaca..."*[65].

The soul's descent from and return to the sun are also the principal ingredients of the theurgy of the neo-Platonist Iamblichus, a disciple of Anatolius and of Porphyry in Alexandria, who established a school of neo-Platonism in Syria in the third and fourth centuries. Iamblichus expounds this theory in his *Commentary of Proclus on the Chaldean Oracles*.

Capricorn, the sign of the Door to Heaven, the door through which souls ascend to heaven, faces the basilica's main entrance to symbolise the beginning of the pathway leading to eternity. The floor decoration, as we have seen, represents the stages of the purification of souls as they journey back through the seven planetary spheres. Thus the way the zodiac is arranged perfectly reflects this symbolism. The depiction of the figure of Capricorn is unusual because, unlike Aries, its body ends with a tail in the shape of a serpent, similar to the tail on the figures reaching

[65] Macrobius *"Commentariorum in somnium Scipionis libri duo"* XII, 1-3; tr. Thomas Taylor, 1823.

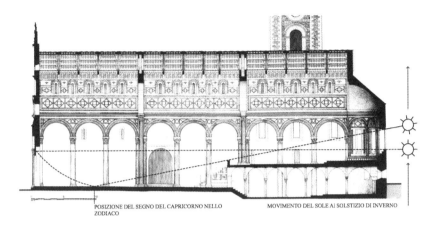

POSIZIONE DEL SEGNO DEL CAPRICORNO NELLO ZODIACO MOVIMENTO DEL SOLE AI SOLSTIZIO DI INVERNO

Fig. 25 - *The path of the sun at the winter solstice*

out towards the griffins in the squinches. This image once again suggests that the opening of the solstitial door cannot occur without the sublimation of the mysterious telluric energy.

It is not clear why the wheel of the zodiac occupies the third register in the marble floor rather than the first. The zodiac probably served as a gnomon. According to chronicler Giovanni Villani, the light penetrating the oculus originally set in the dome of the Baptistry of San Giovanni shone on the zodiac at the summer solstice. In San Miniato the construction of Michelozzo's Chapel of the Crucifix in the 15th century no longer allows us to verify the pathway's journey down the nave, yet if we observe the church in section, we can reconstruct it fairly accurately (fig. 25). The sun's rays could not reach the nave from the middle window in the crypt because their path was barred by the altar. The rays from the middle window in the apse, on the other hand, would pass at the winter solstice through the break in the centre of the wall enclosing the choir, and illuminate the main door into the basilica. As the sun rose in the sky, the ray would pursue its course, moving down the door and travelling up the nave to the sign of Capricorn, where it disappeared, intercepted by the balustrade of the ambulatory outside the choir. I cannot say exactly at what hours the various phenomena occurred, but they certainly did so after dawn and only at the winter solstice. If we recall that, according to

ancient belief, the sun's rays were the vehicle for the souls' ascent and descent, we can understand how evocative it must have been to watch the ray of sunlight gradually moving up the nave and then disappearing in the sign of Capricorn, the Door to Heaven[66]. Thus we may surmise that the two episcopal churches, the Baptistry in the heart of the city and the basilica on the hill overlooking it, were redesigned in the 13th century to frame the two opposing solstitial doors.

We need to ask ourselves to what extent Abbot Joseph was familiar with neo-Platonic doctrine. We have already seen the huge influence wielded by the mystical theology of Dionysius, and that both the *Timaeus* and Macrobius were much read and commented on. They enjoyed especial popularity in the School of Chartres in the 12th century. The *Timaeus* was read in the Latin translation of Chalcidius, an early fifth century Christian author who commented on Plato's work, taking his inspiration from Numeneus and Porphyry. Other Platonic fragments were to be found in the works of the Church Fathers and of Latin authors such as Cicero, Macrobius and Apuleius. Guillaume of Conches wrote his Glosses on Macrobius' Comment on the *Somnium Scipionis* in around 1120, seeking a physical explanation precisely for the doctrine of the souls' descent as evoked by the myth of the Cave of the Nymphs. Macrobius's *Saturnalia* were extremely popular, while Boethius' translation of Porphyry's *Isagoge* was also known; indeed Fulbert, the bishop of Chartres, owned a copy in the early 11th century. So it is clear that the Middle Ages was familiar with the Platonic myth of the descent of souls, in the late and Hermetic exegesis of Porphyry and Macrobius, and that the philosophers in the School of Chartres interpreted and commented on it in their lectures.

In 825 the Emperor Lothair founded eight ecclesiastical universities in Italy, one of which was established in the city of Florence. This

[66] *"But consider this affair clearly as follows: the sun draws all things from the earth, and calls them upwards with a resuscitating and wonderful heat; separating bodies, as it appears to me, as far as to the most exquisite subtilty, and elevating things which are naturally borne downwards. But all such effects as these are arguments of his unapparent powers: for how is it possible that he, who through corporeal heat can produce such effects in bodies, should not much more draw upwards and lead back again fortunate souls, through an unapparent, perfectly incorporeal, divine, and pure essence established in his rays?"* "The Emperor Julian's Oration to the Mother of the Gods", tr. Thomas Taylor, 1793, p. 128, Internet Sacred Text Archive: www.sacred-texts.com.

school, attached to the cathedral and thus under the bishop's control, was known as the "*scola S. Johannis*" in 1186, and it is mentioned in 1203[67] in connection with work then going ahead on the floor decoration in San Miniato and in the Baptistry. We do not know exactly what was taught or what texts were commented on, but we can be certain that Plato, Virgil and Cicero were part of the curriculum.

The Franciscans, meanwhile, had established a school attached to their convent of Santa Croce, which was clearly Platonic in inspiration, to counter the Aristotelianism of the Dominican school in Santa Maria Novella; Dante himself appears to have attended lectures in the Franciscan convent[68]. We have already seen the influence of Guillaume of Conches and of the School of Chartres on Boccaccio and Dante, and later on Marsilio Ficino[69]. The members of the Medici circle that gathered around Cosimo il Vecchio and Lorenzo the Magnificent in the 15th century, in reinterpreting Hermetic symbolism in a Christian vein, were reiterating their continuity with a thoroughly Florentine tradition, of which they considered Dante Alighieri and Guido Cavalcanti to be the most distinguished exponents[70].

Thus the building of San Miniato, with the Platonic symbology and neo-Pythagorean numerology concealed in it, proves that the themes of Hermeticism and of Platonism were well known in Florence between the 11th and 13th centuries, and that they played a crucial part in the theological debate in the city. It is significant that the façade of San Miniato was erected in roughly the same period and in a similar cultural environment as the great Gothic cathedral of Chartres (1194-1220), with its proportions reflecting an equally sophisticated geometric and numerical symbolism.

[67] See Robert Davidsohn, *op. cit.*, vol. I, pp. 1202 and 1204, and vol. VII, p. 227.

[68] This is what Robert Davidsohn thinks, in, *op. cit.*, vol. VII, p. 239.

[69] See Michel Lemoine "Intorno a Chartres. Naturalismo platonico nella tradizione cristiana del XII secolo" Milan, Jaca Book, 1998, p. 103.

[70] See Renzo Manetti "Desiderium Sapientiae" Florence, Giuntina, 1996.

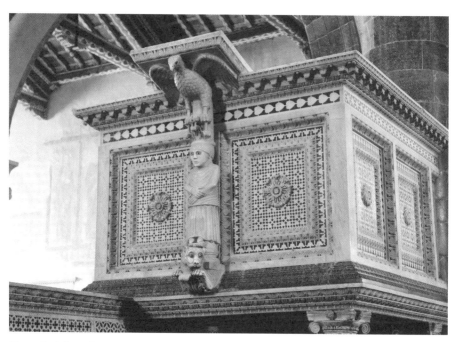

Fig. 26 - *The pulpit*

10. The Cherubim and the Throne

A final and very interesting problem in our attempt to interpret the symbols in the basilica concerns the pulpit, which stands exactly under the second arch of the nave as it leads into the raised choir (fig. 26). The marble lectern is supported on a column from which emerge three marble figures carved in a continuum: an eagle holding up the lectern with its wings, and holding in its claws a leafy bush which appears to spring from the headgear of a man. This man, gazing straight ahead with his arms folded, rests his feet on the base of the column and, at the same time, on the head of a lion that is looking towards the nave. Thus there is a deliberate continuity between the three figures, as though they were a single entity. It is common knowledge that the eagle, the lion, the man and the bull are the symbols of the four Evangelists and that they are shown in that guise around the throne of the Christ Pantocrator in the mosaic in the apse. This symbology harks back to the vision of the Prophet Ezekiel. Ezekiel had a vision of the chariot of God, and its four wheels moved in unison with four animals with human features: "*Each of the four had the face of a man, and on the right side each had the face of a lion, and on the left the face of an ox; each also had the face of an eagle*" (Ez. 1:10). On the animals' heads, a firmament held up the throne of God. This mysterious vision lay at the base of a Jewish esoteric strain that went back to ancient times, involving the so-called mysticism of the Chariot (*Merkabah*). The image was taken up again in the Apocalypse, but the Christians grafted the four figures of the Evangelists onto it because it is on the Evangelists that the Word rests.

The bull is glaringly absent from the San Miniato pulpit. Fred Gettings suggested some years ago that the lion's gaze was directed towards the bull in the zodiac on the mosaic carpet and that this bull was

therefore the missing symbol[71]. I find his thesis hard to accept. The lion is certainly turning his head towards the nave, but it would take a huge leap of the imagination to deduce from that he is staring at the figure of Taurus in the zodiac. Thus the mystery of the missing figure remains.

Unless, perhaps, Ezekiel himself can lend us a hand in solving it. The prophet describes a second vision of the Chariot in his book, but this time he names the figures that he can see. They are Cherubim standing before the throne of God: "*Each of the Cherubim had four faces: One face was that of a cherub, the second the face of a man, the third the face of a lion, and the fourth the face of an eagle*" (Ez. 10:14). As we can see, this time Ezekiel makes no mention of a bull. The first figure is a cherub, who is ineffable and indescribable, thus the visible aspects of the Cherubim are only three in number: the eagle, the man and the lion. These are the same figures that we have seen in the marble pathway on the nave floor, in which the only bull depicted is the Taurus figure in the zodiac. We may conclude from this that the figures on the pulpit are not the Evangelists at all, but Ezekiel's Cherubim standing guard before the choir, the basilica's *Sancta Sanctorum*.

This hypothesis is borne out once again by the Hymn for the cathedral of Edessa, which mentions the image of Cherubim held up by columns, and it is situated precisely in the choir: "*The ten columns that support the Cherubim of the choir represent the ten Apostles who fled at the time when our Lord was crucified*". If fully ten columns were required to support it, it must have been a fairly complex figure rather than just the statue of an angel. Oriental influence is evident in the decoration of the basilica of San Miniato. Furthermore, we have seen that Christianity reached Florence from Syria and that religious ties between the city and the East were still very close in the Middle Ages.

Candelabra are depicted on the three nave arcades. It is of major symbolic significance that the arch over the pulpit contains a different number of candelabra from the other two arcades, which contain four on each side. The arch standing over the entrance to the sanctuary, on

[71] Gettings, p. 58.

the other hand, contains seven, three on one side and four on the other. A passage in the Apocalypse tells us that *"there were seven lamps of fire burning before the throne, which are the seven Spirits of God"*(Apocalypse 4:5). Thus the Cherubim in the pulpit are guarding the basilica's *Sancta Sanctorum*, the sanctuary enclosed by a high wall adorned with marble, and it appears to be no mere coincidence that the great arches scanning the division of the nave into three parts are regulated by the golden ratio, thereby indicating the uniquely sacred nature of the sanctuary area.

The number of steps leading up to the sanctuary is also symbolic. They number sixteen, in other words two times eight, a number which we have encountered several times in the mystic pathway on the marble floor as a doorway introducing the initiated into a heavenly space. There are seven steps, on the other hand, leading up from the crypt to the nave, indicating that the journey from the region of darkness and silence leads to the dimension of life and of space-time, marked by the seven days of creation.

Yet there may be another explanation for the absence of a bull on the pulpit lectern. This second interpretation is of the utmost simplicity and it, too, is consistent with the symbolism both of the façade and of the marble pathway. The symbols of the Evangelists have nothing to do with it at all.

The eagle is the master of the heavenly vault, just as the lion is the master of the animal kingdom. The union of their two regal natures spawns the griffin, the symbol of Christ, whose image is a constant throughout the marble pathway. But the link between the two worlds is man, for he partakes of both their natures. He rests his feet on the master of the animal kingdom, because it is written in Genesis: *"Let them have dominion over the fish of the sea and over the birds of the heavens and over the livestock and over all the earth and over every creeping thing that creeps on the earth"* (Gn.1:26). His head, in other words his intellect, is solidly anchored within the eagle, in the vault of heaven. Thus he is a microcosm embodying within himself the entire macrocosm, and as Pico della Mirandola was to write some two hundred years later: *"I have placed you at the very centre of the world, so that from that vantage point you may with greater ease glance round about you on all that the world contains. We have made you a creature*

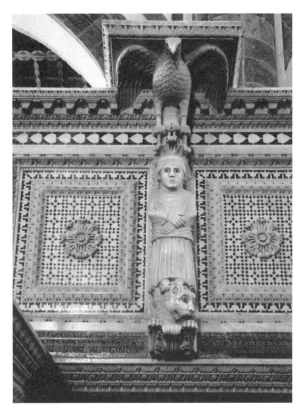

Fig. 27 - *Detail of the pulpit*

neither of heaven nor of earth, neither mortal nor immortal, in order that you may, as the free and proud shaper of your own being, fashion yourself in the form you may prefer. It will be in your power to descend to the lower, brutish forms of life; you will be able, through your own decision, to rise again to the superior orders whose life is divine"[72].
The eagle and the man are both gazing straight ahead, while the lion turns towards the nave. The lion belongs to the era of time, to the dimension of movement and of becoming, while the eagle and man are

[72] Pico della Mirandola "Oration on the Dignity of Man" 21-23, tr. Cosma Shalizi, ed. Peter Grubbs, Santa Fe Institute, 1994.

Fig. 28 - *The inscription on the threshold of the east door of the basilica*

already immersed in eternity, on the eighth day on which becoming subsides, subdued by the power of the Word, their Lord (fig. 27).

All of the symbology enshrined in the decoration of San Miniato, starting on the façade, moving through the marble pathway and progressing up to the pulpit and the internal decoration, thus seems to lead to the choir and apse seen as a manifestation of the Throne of God, a kind of Jacob's ladder linking heaven and earth, a sublime place where the spirit infuses base matter.

The basilica is oriented towards the southeast in order to receive the sun's rays at the winter solstice, the door through which souls ascend to heaven, and Capricorn, the sign of the Door to Heaven, is set before the entrance to the church as a warning to all who enter that, in penetrating the sacred space, they are entering a place which is not simply a passage to heaven, it is already part of it. As Jacob exclaimed: *"Terribilis est locus iste"*. This brings us back to where we started, to that blessed Place where earth joins heaven, a Place that corresponds both to certain special areas on our planet and to a spiritual state which those places dispense with greater largesse. It is significant that the sill of the so-called Holy Door, the one on the left-hand side

of the façade of San Miniato, carries an inscription that reads *"Haec est Porta Coeli"*, or *"This is the Door to Heaven"* (fig. 28). Of the three doors in the façade of San Miniato, this is the one that ideally faces east, and sacred tradition demanding that it be kept permanently closed highlights the connection between the basilica and the Temple in Jerusalem. Ezekiel tells us that it is through the east door that God's Presence takes possession of its temple, thus this door is reserved for God and barred to mortal man: *"Then the man brought me back to the outer gate of the sanctuary, the one facing east, and it was shut. The Lord said to me, 'This gate is to remain shut. It must not be opened; no one may enter through it. It is to remain shut because the Lord, the God of Israel, has entered through it'"*[73].

So the Latin inscription really does seem to demand that we read it literally, as an invocation to Christ to take possession of the Throne prepared for Him, just as the Prophet Ezekiel watched the Glory of God take possession of His Temple. That Glory came through the door facing east: *"The glory of the Lord entered the temple through the gate facing east... Son of man, this is the place of **my throne** and the place for the soles of my feet. This is where I **shall dwell** among the Israelites forever"*[74].

The time has now come to interpret the deeper significance of Abbot Joseph's inscription. In the light of the symbolic message permeating the basilica, we may interpret it as follows:

> *Impressing the heavenly rule before this valve,*
> *setting out the measures and verifying their harmony,*
> *Joseph caused this work to be made.*
> *Therefore I pray to Christ*
> *that He make it for ever His home.*
> *In this sacred space time and death lose their power. 1207.*

The great basilica opens wide the doors of eternity and its sacred space belongs to the eighth day, the day on which time crumbles and the luminous dimension of the spirit streams in in triumph. The leaves

[73] Ezekiel, 44:1-2.
[74] Ezekiel, 43:4-7.

of the doors, the valves of the shell, to which Joseph refers are not the wooden doors of the basilica. They are the doors of that invisible gateway whose key is there for all to see, yet hidden from all. It is un-veiled only to a few, for to find it requires unhurried patience. Yet it is there, ready to open up its passage. If we wish to find it, we have but to learn the language of the angels.

Printed in Florence
by Polistampa
June 2011